FROM BOTANY TO BOUQUETS

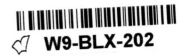

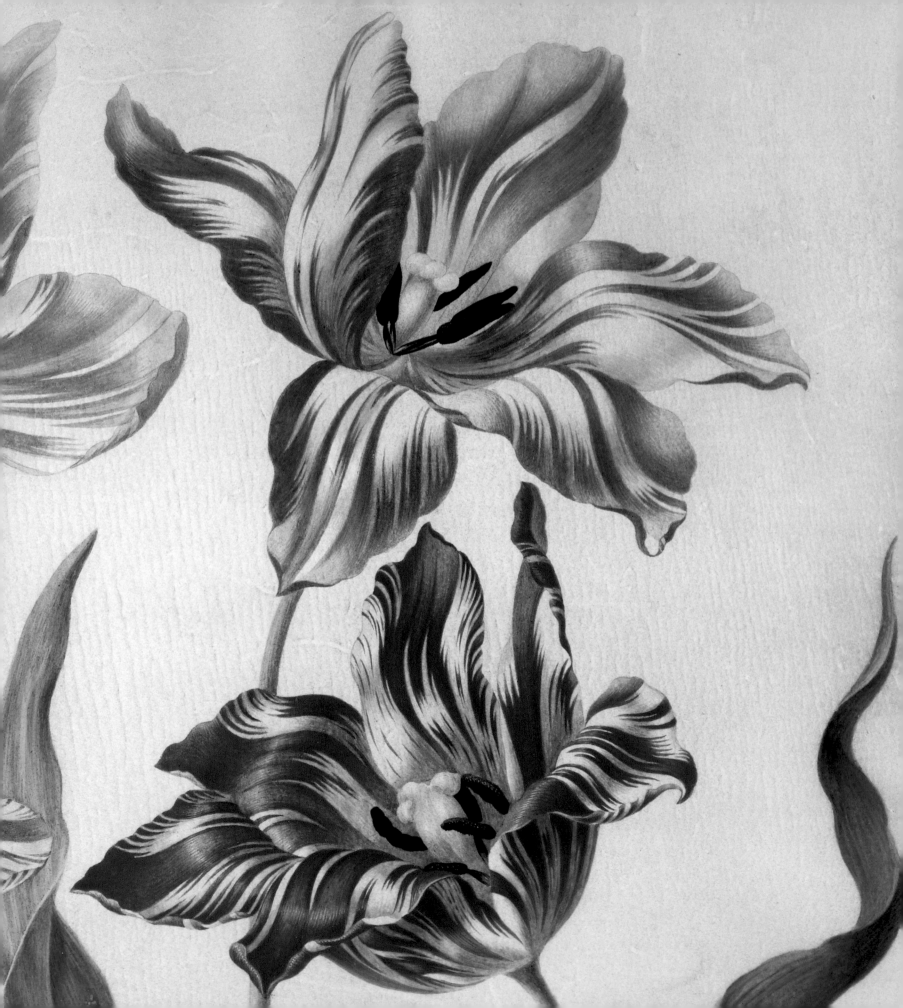

FROM BOTANY TO BOUQUETS

Flowers in Northern Art

Arthur K. Wheelock Jr.

National Gallery of Art, Washington

Shell Oil Company Foundation, on behalf of the employees of Shell Oil Company, is proud to make possible this presentation to the American people.

The exhibition was organized by the National Gallery of Art

National Gallery of Art, Washington
31 January – 31 May 1999

This book was produced by the Editors Office, National Gallery of Art
Editor-in-chief, Frances P. Smyth
Editor, Julie Warnement
Designer, Chris Vogel

Typeset in Joanna
Printed on Lustro Dull by Schneidereith & Sons, Baltimore

FRONT COVER: Ambrosius Bosschaert the Elder, *Bouquet of Flowers in a Glass Vase* (detail, cat. 11)

BACK COVER: Crispijn van de Passe the Younger, *Crocus* (detail, cat. 57)

FRONTISPIECE: Antoni Henstenburgh, *Five Tulips* (detail, cat. 31)

Note to the Reader
Unless otherwise specified, images in books are listed under the book's author.

Dimensions are given in centimeters, followed by inches in parentheses.

Library of Congress Cataloging-in-Publication Data

Wheelock, Arthur K.
From botany to bouquets: flowers in Northern art / Arthur K. Wheelock, Jr.
 p. cm.
Catalog of an exhibition held at the National Gallery of Art, Jan. 31–May 31, 1999.
Includes bibliographical references.
ISBN 0-89468-238-5

1. Art, Dutch—Exhibitions. 2. Art, Modern—17th–18th centuries—Netherlands—Exhibitions. 3. Art, Flemish—Exhibitions. 4. Art, Modern—17th–18th centuries—Flanders—Exhibitions. 5. Flowers in art—Exhibitions.
I. National Gallery of Art (U.S.) II. Title.

N6936.W48 1999
758´.42´09492074753—dc21 98-51807
 CIP

CONTENTS

FOREWORD

The Dutch Cabinet Galleries, created with the generous support of Juliet and Lee Folger / The Folger Fund, have provided new opportunities for the collecting and presentation of seventeenth- and eighteenth-century Dutch art at the National Gallery. The rooms—intimate in scale and fitted with specially designed wall cases—are ideally suited for displaying small paintings of the type the Dutch so often executed as well as three-dimensional objects and works on paper. The Shell Oil Company Foundation has generously enhanced the Dutch Cabinet Gallery program by providing for a series of exhibitions, which began last year with the highly acclaimed *Collector's Cabinet*. We owe particular thanks to Jack E. Little, Shell's president and chief executive officer, for continuing Shell's tradition of support for Dutch initiatives, which include *The Age of Bruegel: Netherlandish Drawings in the Sixteenth Century* (1986); *Piet Mondrian: 1872–1944* (1995); and *Jan Steen: Painter and Storyteller* (1996).

From Botany to Bouquets: *Flowers in Northern Art*, the second exhibition in the Dutch Cabinet series, brings together a magnificent group of sixteenth- and seventeenth-century flower still-life paintings, watercolors, manuscripts, and botanical books. Organized by Arthur K. Wheelock Jr., curator of northern baroque paintings at the Gallery and author of this catalogue, the exhibition traces the development of the flower still-life genre, from its very beginnings in the margins of prayer books, to its full "flowering" in the still life paintings of Jan Davidsz. de

Heem and Jan van Huysum. The elegant installation, which allows the viewer to appreciate the complex relationships among paintings, manuscripts, printed books, and individual watercolor studies of flowers, is the work of Mark Leithauser, our chief of design.

We are indebted to the many private lenders and public institutions who have generously lent works of art, particularly Dumbarton Oaks, The Folger Shakespeare Library, the Library of Congress, the North Carolina Museum of Art, the Philadelphia Museum of Art, and the Wadsworth Atheneum, Hartford, Connecticut. Without them we could not have told the story that unfolds around these radiant images.

Earl A. Powell III
Director

DETAIL: Jan Davidsz. de Heem, *Vase of Flowers* (cat. 16)

LENDERS TO THE EXHIBITION

Maida and George Abrams

Mr. Pieter C.W.M. Dreesmann

Dumbarton Oaks, Washington

The Folger Shakespeare Library,
Washington

Mrs. Teresa Heinz

The Library of Congress, Washington

Mrs. Paul Mellon

National Gallery of Art, Washington

North Carolina Museum of Art, Raleigh

Philadelphia Museum of Art

Private Collections

Wadsworth Atheneum, Hartford

The Henry H. Weldon Collection

INTRODUCTION

The artists who created the flower still lifes in this exhibition could convey the delicacy of blossoms, the organic rhythms of stem and leaf, and the varied colors and textures of each and every plant. They could capture the fragile beauty of flowers and the sense of hope and joy they represent. Their bouquets come alive with flowers that seem so real we almost believe their aroma—and not the artist's brush—has drawn the dragonflies and bees to their petals.

However, the great appeal of seventeenth-century Dutch and Flemish flower still lifes stems not only from their lifelike qualities but also from the fascinating philosophical issues they raise about the relationship of art to nature, to poetry, and to life itself. These artists sensitively combined various species of flowers—among them tulips, roses, columbine, and lilies of the valley—in pleasing and dynamic compositions that feel true to life. Yet many of the bouquets they painted could never have existed in nature because the flowers they imaginatively combined would not have blossomed at the same time of the year. Indeed, this ability to create effects that Nature could not equal was often extolled by contemporary patrons, poets, and critics.

By the early seventeenth century, the collecting of flowers, as well as the painting of flowers, had become a central passion in The Netherlands. Botanists and private collectors eagerly sought to acquire unusual and exotic flowers, many of which were imported from the Balkan peninsula, the Near and Far East, and the New World. Bulbous plants, especially the tulip, were particularly admired—their bright colors and dramatic forms accent numerous seventeenth-century still lifes.

Despite the apparent realism of these flower bouquets, few Dutch still lifes were painted from life. In general, the rarity and great expense of exotic flowers prohibited artists from having easy and regular access to them. Tulips, in particular, were exceedingly expensive, so much so that during the tulipmania of the mid-1630s houses were actually traded for bulbs. Because of this great fascination with tulips, stemming from the unpredictability of their colors and shapes, artists like Jacob Marrel produced "tulip books" to provide images for prospective buyers. Sheets from such a book, in which each exotic tulip is carefully depicted and named, are included in this exhibition.

The exhibition, which examines the origins of flower painting with a selection of botanical treatises, manuscripts, and watercolors by outstanding sixteenth- and seventeenth-century printmakers and draftsmen, also raises fascinating questions about flower symbolism. For example, certain flowers, such as the rose, lily, and violet, were traditionally associated with Christian traditions, and it seems probable that religious concepts were occasionally illustrated in flower bouquets. Other still

lifes, particularly those that place flowers together with skulls, clearly refer to the transitory nature of life. By introducing such spiritual ideals and moral concerns into their works, these painters placed their still lifes within a broad, humanistic context, which they achieved with great enthusiasm, dignity, and intelligence.

I would like to acknowledge those who have helped to make this exhibition a reality, particularly those colleagues who lent their enthusiastic support and guidance in helping select and prepare loans: Julie Ainsworth, Jean Caswell, Mark Dimunation, Rachel Doggett, Deborah Evans, David Koetser, Joe Mills, Linda Lott, Katherine Crawford Luber, Cynthia Pinkston, Rob Shields, Peter Sutton, Steven Umin, Dennis Weller, and Tony Willis. I am also extremely grateful to Sally Wages, who shared not only her library, but also her good counsel about this fascinating and complex subject.

At the National Gallery, the loan arrangements were expertly handled by Jennifer Fletcher Cipriano from the department of exhibitions, headed by D. Dodge Thompson, and by Melissa Stegeman and Michelle Fondas from the registrar's office, headed by Sally Freitag. Susan Arensberg coordinated the educational component of the exhibition. Once again, I had the good fortune to work closely with Mark Leithauser, chief of design, and other members of his outstanding staff. Among those who helped coordinate the installation of this show were Linda Heinrich, Gordon Anson, John Olson, Anne Kelley, and Jane Rodgers. Their work was abetted by the contributions of members of the conservation department, particularly Hugh Phibbs and Elaine Vamos. Pierre Richard headed the team of art handlers who installed the works.

The catalogue benefited from the conceptual guidance and expert editing of Julie Warnement. The elegant design of both catalogue and brochure was created by Chris Vogel. Sara Sanders-Buell in the department of visual services gathered color transparencies, while Dean Beasom, Philip Charles Jr., Lorene Emerson, Lyle Peterzell, and Lee Ewing photographed works borrowed from a number of private collectors.

I would also like to thank those colleagues at the Gallery who willingly shared works under their care: Neal Turtell, executive librarian, and Andrew Robison, Andrew W. Mellon Senior Curator and head of the department of prints and drawings, who was assisted by Margaret Grasselli, Gregory Jecmen, and Virginia Clayton.

Finally, to members of my own department, I offer my thanks for their invaluable help. Esmée Quodbach, who was my assistant, and Isabelle Knafou, an intern from Université de Lille, France, were instrumental in the early stages of the project. Phoebe Avery, an intern from the University of Maryland, and Quint Gregory, assistant in the department, thoughtfully commented on the manuscript. Ana Maria Zavala, our staff assistant, diligently handled most of the administrative details.

Arthur K. Wheelock Jr.

DETAIL: Ludger tom Ring the Younger, *Vase of Wild Flowers on a Ledge* (cat. 23)

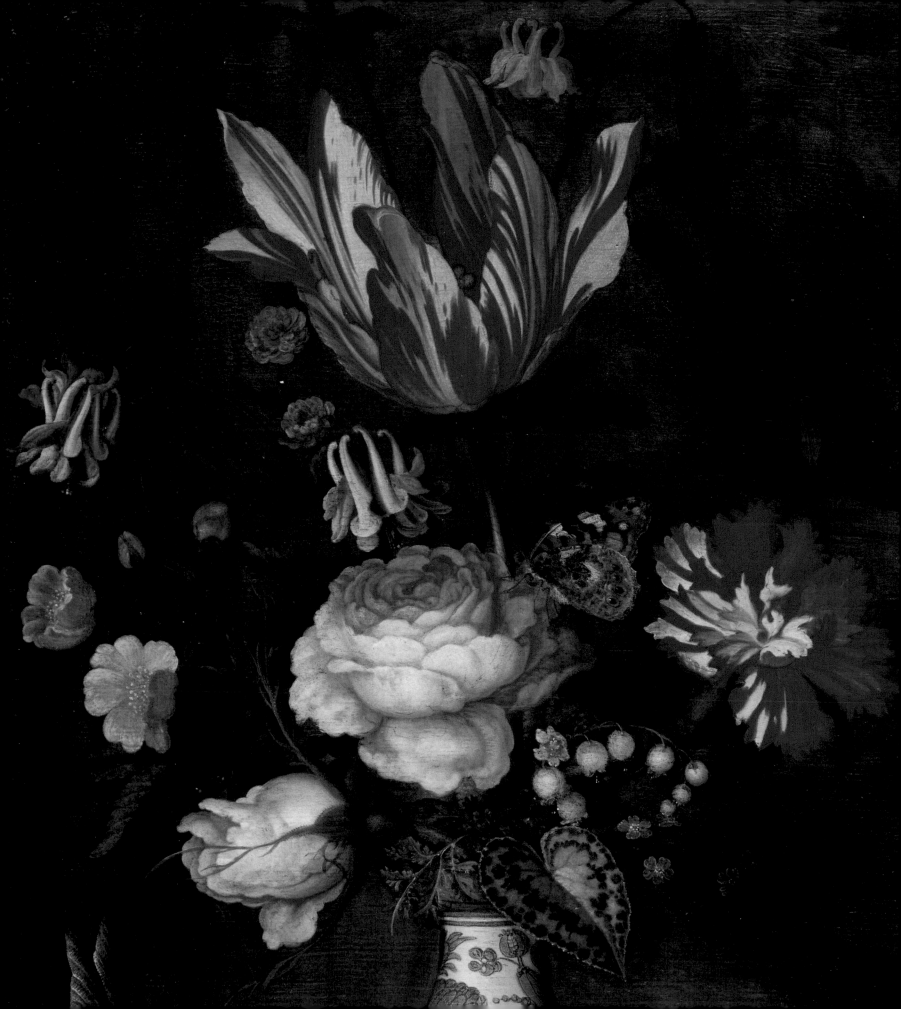

FROM BOTANY TO BOUQUETS
Flowers in Northern Art

The Realism of Dutch and Flemish Still-Life Painting

Balthasar van der Ast knew how to paint flowers. He could capture their organic rhythms, whether those caused by the weight of blossoms or the opening of petals. He carefully observed the patterns of their colors and sought to suggest their varied textures. He sensed how different flowers, among them tulips, roses, columbine, and lilies of the valley, could best be combined to make a pleasing and dynamic composition, one that feels true to life even if no such arrangement could exist in nature. Most of all, he painted flowers with the tenderness and delicacy of one who valued their fragile beauty and the sense of hope and joy that they represent.

Van der Ast (1593/1594–1657) was not the only Dutch artist to achieve such remarkable effects in his paintings. However, as one whose works epitomize the finest qualities of Dutch and Flemish flower painting, he serves as an excellent introduction to this genre. Moreover, he holds a special place in the story of seventeenth-century flower painting in the new style he forged, one that transformed the direction this type of painting would take.

Van der Ast's stylistic innovation, which he introduced in a number of floral compositions during the mid-1620s, was to free bouquets of flowers from the tightly constricted compositions painted by his predecessors, Ambrosius Bosschaert the Elder (1573–1621) (fig. 29)

and Roelandt Savery (1576–1639) (fig. 27). Van der Ast allowed light and air to pass in and around stems, leaves, and individual blossoms. In his *Flowers in a Wan-li Vase* (fig. 1), light shining from the left both accents individual blossoms and models their forms. Insects further enliven the scene with a sense of movement, for a dragonfly alights on a variegated red-and-white carnation and a butterfly rests on the petals of the centrally placed pink rose. Below, a lizard arches up to peer at the bouquet, as though responding to the menacing glare of the grasshopper (depicted in blue on the Wan-li vase), whose striped body playfully echoes the rhythm of the stems of the adjacent cherries. Like the dramatic red-and-yellow striped tulip crowning this composition, many of the blossoms are daringly open, a veritable explosion of color and form that belies the very notion that these paintings should be called still lifes.

So vivid is the realism of this flower bouquet that one can hardly believe Van der Ast carefully composed it by imaginatively combining drawings of individual plants, berries, and insects.[1] And yet all evidence indicates that he worked in this manner. Not only do identical blossoms appear in various paintings, but his floral arrangement would never have formed an actual bouquet since the flowers he depicted did not blossom during the same season. Nevertheless, Van der Ast and his contemporaries would have considered this work a

DETAIL: Balthasar van der Ast, *Flowers in a Wan-li Vase* (cat. 5)

13

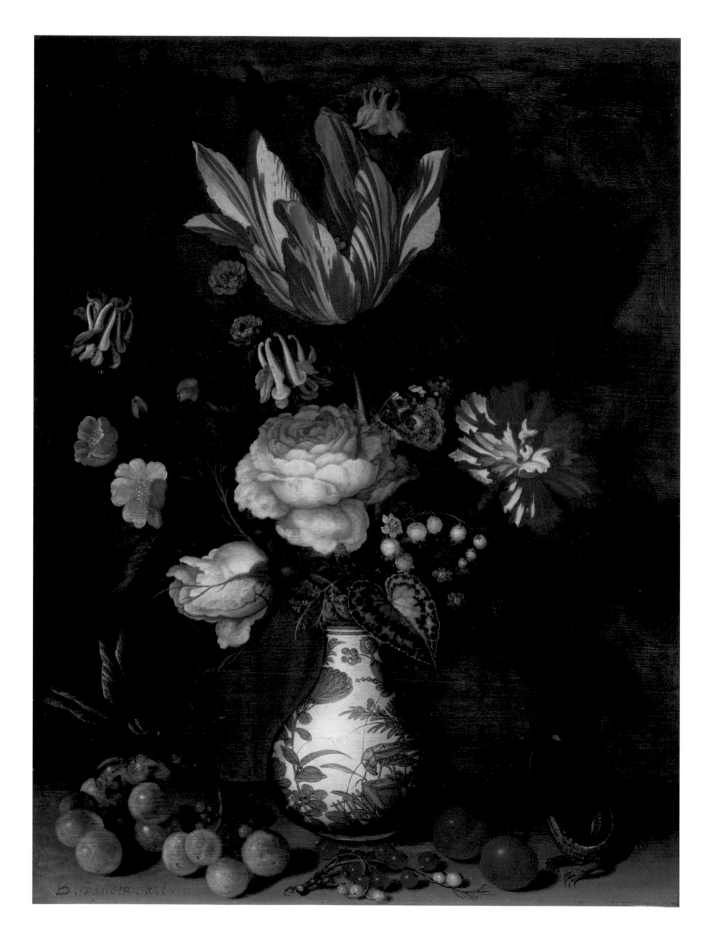

painting made "naer het leven," a term generally understood today as a "painting from life," but also interpreted in the seventeenth century as a "lively" or "lifelike" image.[2]

Perhaps more than any other genre of painting, still lifes, and flower still lifes in particular, depended upon a sense of liveliness to succeed as works of art. Patrons, poets, and critics alike provided the highest accolades to still-life artists who could not only emulate nature but also make their paintings seem alive. Cardinal Federico Borromeo, writing in 1628 about a painting by Jan Brueghel the Elder (1568–1625), described how even in the dead of winter he imagined the aromas of the blossoms the artist had painted: "Then when winter encumbers and restricts everything with ice, I have enjoyed from sight—and even imagined odor, if not real—fake flowers...expressed in painting." In 1646 the poet Joachim Oudaan envisioned a painting of a bouquet of flowers as actual blossoms, ones that rivaled nature in their beauty: "No trained rose arbor gives more beautiful roses. No tulips, no narcissus ever met so suitable, so fine a likeness." Oudaan also stressed that the bouquet had the advantage that it would never wither: "[The rose] will endure in secure colors, planted to measure by Zeuxis' hand, much better than in damp sand." Constantijn Huygens wrote a

poem in 1645 that actually envisions a contest between Mother Nature and the flower painter Daniel Seghers (1590–1661) (fig. 40). The contest is won by the artist, whose painted flowers, which create "the fragrance of roses,...rendered the real one a shadow." Finally, in 1661 the critic Cornelis de Bie extolled Seghers for creating flowers so real that live bees would want to settle on them. De Bie exclaimed: "Life seems to dwell in Father Seghers' art."[3]

The enormous delight flower paintings engendered helps account for the large number of such works created throughout the seventeenth century. However, flower paintings produced in The Netherlands were remarkable for not only their number, but also their quality. The high standards to which flower still lifes were held meant that only the most gifted artists could earn a living painting them. Moreover, as is evident from the comments of Borromeo, Oudaan, and De Bie, the theoretical context for these works was quite varied, and involved, among other concerns, the relationship of art to nature, to poetry, and to life itself.

The Importation of Exotic Flowers

By the time Van der Ast painted *Flowers in a Wan-li Vase* in the mid-1620s, flowers as well as paintings of flowers had become a central passion for collectors and art lovers throughout Europe, but particularly in The Netherlands. Spurred

on by the influx of exotic species imported from the Balkan peninsula, the Near and Far East, and the New World, collectors eagerly sought to acquire unusual flowers, which they cultivated in their gardens (fig. 16). They particularly admired bulbous plants such as the iris, the narcissus, the scarlet lily, the fritillaria, and, above all, the tulip—species whose bright colors and dramatic forms frequently accent flower paintings by the finest early seventeenth-century Dutch and Flemish painters.[4]

The parallels between the visual appeal of these new species and the sudden flourishing of flower painting cannot be overestimated. Although flowers had always had multiple associations—ranging from love and purity to the richness of nature's bounty, the fragility of man's existence on earth, and the sense of smell—the idea that they were desirable primarily for their beauty and rarity, and were worthy of being the subject of an independent work of art, only developed at the end of the sixteenth century.

This widespread fascination with flowers and gardens grew out of three pictorial traditions that were current in the sixteenth century: illusionistic floral motifs in border illustrations of Books of Hours, which had a religious foundation; Renaissance naturalism, with theoretical and aesthetic considerations at its base; and botanical illustrations, an essentially scientific development due, in part, to advances in botany. Although

FIGS. 4–5. Anonymous, *Hellebore* (left, cat. 28) and *Smirnium* (right, cat. 29) from *Iconographica Botanicae*, c. 1500, bodycolor on paper, Dumbarton Oaks, Washington, Trustees for Harvard University

discover cures based on plant extracts. These ancient authors, particularly Dioscorides, were so revered during the Middle Ages that it was assumed they had discovered every species and answered every question that could be raised about the plant kingdom.[12]

During the Renaissance, however, scholars began to question the authority of these authors when they discovered numerous plants that Dioscorides and the other ancient authors had not included in their studies. Renaissance scholars also came to realize that close examination of plants could reveal new, and sometimes conflicting, information about them.[13] Moreover, the visual information that accompanied classical texts left much to be desired, for images in most manuscript illustrations based on antique sources were quite generalized (see figs. 4, 5).[14]

The new Renaissance attitude toward the authority of antiquity, with its corollary, a new-found emphasis on close observation of nature, is nowhere more evident than in the theoretical approach to art adopted by Albrecht Dürer (1471–1528). Dürer's most explicit commentary on the importance of observing nature appears in his *Vier Bücher von Menschlicher Proportion* (Nuremberg, 1528):

> But life in nature manifests the truth of these things. Therefore observe it diligently, go by it and do not depart from nature arbitrarily, imagining to find the better by thyself, for thou wouldst be misled. For, verily, "art" [that is, knowledge] is embedded in nature; he who can extract it has it.[15]

Although Dürer's recommendation to observe nature diligently was not specifically related to the study of individual plants, he applied this approach in some remarkable nature studies that forever transformed the way artists depicted birds, flowers, and seemingly insignificant tufts of grass.[16] Almost immediately, other German artists began to emulate Dürer's style, which gave birth to an extraordinary tradition of careful nature studies that culminated in the work of Ludger tom Ring the Younger (1522–1584) (fig. 14) and Joris Hoefnagel (1542–1600) (fig. 25).

This magnificent *Tuft of Cowslips* (fig. 6) is one such work from the early sixteenth century. In this gouache study on vellum, inscribed 1526/AD, the artist has carefully observed the organic forms of the plant, not only by indicating the rhythms of its leaves, stems, and blossoms, but also by capturing the nuances of color that enliven its form.[17] The cowslip (*Primula veris* L.), commonly referred to as a primrose, was traditionally included in herbals, which may account for its appearance as a separate nature study. Botanists recommended cowslips for a number of cures, including gout and palsy. Powder ground from its roots was thought to alleviate stones in the kidneys and bladder.

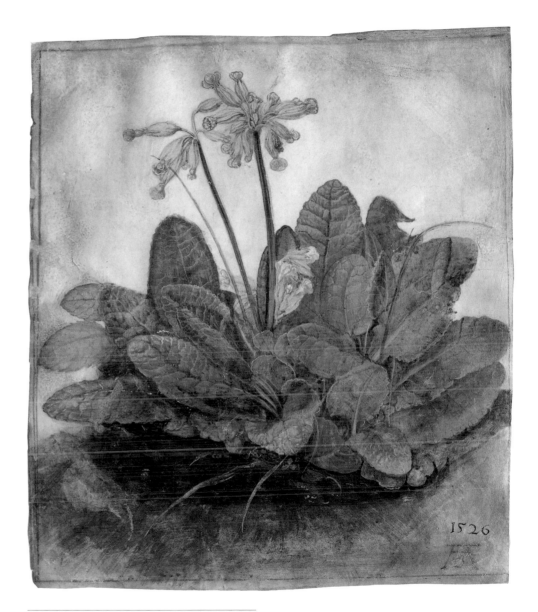

FIG. 6. Albrecht Dürer, *Tuft of Cowslips* (cat. 30), inscribed "1526/AD," gouache on vellum, National Gallery of Art, The Armand Hammer Collection

FIG. 7. Otto Brunfels, *Narcissus* (cat. 50) from *Herbarum Vivae Eicones* (Strasbourg), 1530, hand-colored, Dumbarton Oaks, Washington, Trustees for Harvard University

Printed Herbals

Dürer's immediate impact on the evolution of printed herbals was profound. One of his more talented students, Hans Weiditz II (before 1500–1536), made a number of remarkable watercolor plant studies for the botanist Otto Brunfels (1464–1534), who published his important herbal in 1530. The woodcuts made from Weiditz' studies were so much more lifelike than the stylized images appearing in late fifteenth-century herbals that Brunfels proudly titled his work *Herbarum Vivae Eicones* (*Living Portraits of Plants*).[18] Weiditz intended his highly accurate botanical drawings to aid in the identification of plants. Consequently, unlike Dürer or the artist who made *Tuft of Cowslips*, he isolated individual plants and depicted their roots.[19] A particularly beautiful example of his work is this hand-colored depiction of the narcissus, which he portrayed in three different stages of development (fig. 7).

In the wake of Brunfels' herbal, a virtual flood of botanical works appeared in major typographic centers throughout Europe: between 1531 and 1600 over 650 botanical books were published in Italy, Germany, France, and the Southern and Northern Netherlands.[20] This extraordinary outpouring resulted not only from scientific advances in the description and classification of plants, but also from the influx of newly discovered species, both in Europe and from around the world. During the course of the century, the number and types of plants botanists had identified grew from approximately one thousand to six thousand species.[21] Nevertheless, these publications only succeeded because of the widespread interest in plants and their propagation at all levels of society. Even poor students actively sought to acquire rare plants by hunting for them in the wild or by trading seeds with friends or travelers.[22]

As interest in botany spread during the sixteenth century, the character of herbals changed. While many remained sumptuously produced and expensive, others were clearly intended for a middle-class, less literate clientele. One relatively small herbal, published midcentury by Christian Egenolph (1502–1555) in Frankfurt, contains a title page depicting a common man hard at work in his own garden (fig. 8). This volume, which has virtually no text other than the Latin and German names of the approximately eight hundred clearly illustrated and hand-colored plants, was extensively annotated by an early Dutch or Flemish owner who probably used it as a practical aid. Indeed, the impression of various plants dried between its pages, similar to those that must have at one time been collected in Books of Hours, can still be seen (fig. 9). And the flora depicted, including here a strawberry plant, an iris, and a hellebore (fig. 10), is, despite the small scale of the images, far more easily identifiable than that in the manuscript illustration executed less than half a century earlier (fig. 4).

For his small publication Egenolph relied heavily on the excellent illustrations in the important herbal *De Historia Stirpium Commentarii Insignes* (Basel, 1542), published by Leonhart Fuchs (1501–1566), professor of medicine at the Universities of Ingolstadt and Tübingen. With its descriptions of four hundred German and one hundred exotic plants, Fuchs' herbal set a new standard for

FIGS. 8–10. Christian Egenolph, *Title Page* (top left), *Dried Plants* (top right), and *Variety of Plants* (right, cat. 54) from *Herbarium. Arborum, Fruticum Imagines* (Frankfurt), c. 1550, hand-colored, The Folger Shakespeare Library, Washington, Gift of Mary P. Massey

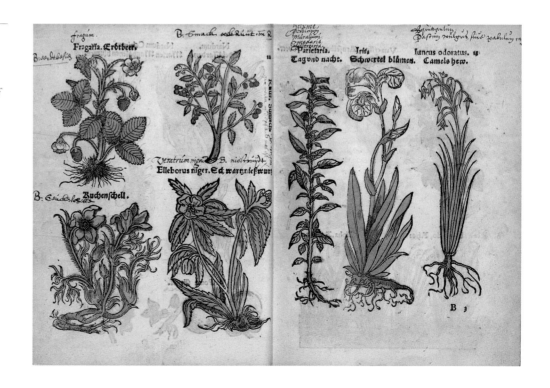

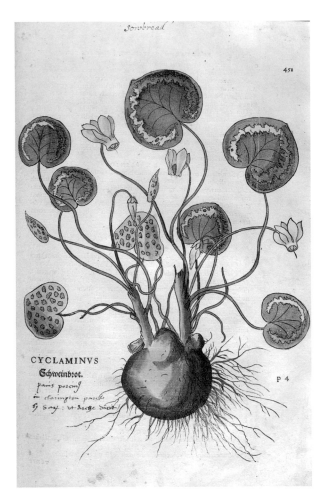

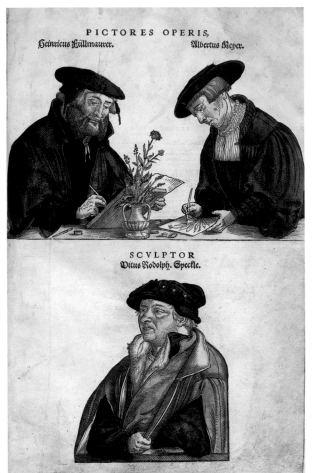

FIGS. 11—12. Leonhart Fuchs, *Cyclamen* (top left) and *Portrait of Three Artists at Work* (top right, cat. 55) from *De Historia Stirpium Commentarii Insignes* (Basel), 1542, hand-colored, Dumbarton Oaks, Washington, Trustees for Harvard University

FIG. 13. Rembert Dodoens, *Wild Poppies* (cat. 52) from *Cruijdeboeck* (Antwerp), 1552–1554, hand-colored, Dumbarton Oaks, Washington, Trustees for Harvard University

comprehensiveness.[23] Its high quality, large woodcut illustrations—for example, this boldly patterned cyclamen plant (fig. 11) —were equally important. Indeed, so proud of these illustrations was Fuchs that he included a full-page plate of the artists at work: Albrecht Meyer drawing a plant from life; Heinrich Fullmaurer transferring a drawing to a wood block; and Veit Rudolf Speckle, who cut the blocks (fig. 12).[24]

The refined woodcut images made from Meyer's drawings were left unshaded because they were intended to be hand colored. Fuchs wrote in his introduction:

> As far as concerns the pictures them selves, each of which is positively delincated according to the features and likeness of the living plants, we have taken peculiar care that they should be most perfect; and, moreover, we have devoted the greatest diligence to secure that every plant should be depicted with its own roots, stalks, leaves, flowers, seeds and fruits.[25]

Indeed, the expressive characterization of plants in this herbal, such as the flowing image of wild basil on the page facing the portraits of the three artists, had a profound impact on virtually all subsequent publications.

The man most responsible for bringing Fuchs' work to The Netherlands was Rembert Dodoens (1517–1585), a scholar who served as city physician in Meche-

len until 1575, when he moved to Vienna to become the personal physician of Emperor Maximilian II. In 1543 Dodoens had brought Fuchs' treatise to a much broader audience by translating it into Dutch.

Dodoens published his own herbal, *Cruijdeboeck*, in Antwerp in 1554.[26] The dependencies on Fuchs' *De Historia Stirpium Commentarii Insignes* are many: 500 of the 710 illustrations, for example, are copies of Fuchs' images. Nevertheless, Dodoens was extremely proud of the realistic images of plants in his herbal, including many from the Low Countries that had not previously been identified. They were, according to him, "naer dat leven ghcconterfeyt," a term that could mean "drawn from life" but, since so many of the illustrations were copied from Fuchs, more probably should be translated as "drawn lively" or "in a lively fashion."[27] As is evident in these hand-colored images of wild poppies (fig. 13), the woodcuts are expressively carved and indicate the distinctive character of each plant's roots, leaves, stems, and blossoms. With each image, Dodoens also provided a careful description of the plant's habitat, growing season, and special medicinal attributes—information that expanded upon the utilitarian character of his publication.[28]

A Precursor to Seventeenth-Century Flower Painting

The plethora of native plants described and depicted by botanists such as Fuchs and Dodoens expanded the range of herbs and flowers deemed acceptable for artistic representation. Nowhere is this development more evident than in the work of Ludger tom Ring the Younger, who created this extraordinary floral still life at some point during the 1560s (fig. 14). With seeming abandon, Tom Ring filled this Venetian glass vase with an array of spring and summer wild flowers, a veritable explosion of colors and shapes so fresh in appearance that one can almost imagine them being gathered that very day. With so many species spilling out of the narrow mouth of the vase, it is not surprising that a number of blossoms, strewn across the tabletop, could not fit.

Although Tom Ring made a number of plant studies that follow directly in the tradition of Albrecht Dürer, he also infused many of his flower paintings with religious symbolism.[29] Indeed, his earliest floral bouquets appear in biblical scenes, in which he only included flowers imbued with traditional religious symbolism. When he began painting independent floral bouquets in the mid-1560s, the flowers he depicted, such as lilies, and the inscriptions he placed on the vases indicate that these works had allegorical or religious significance.[30] As a pure celebration of nature's bounty, *Vase of Wild Flowers on a Ledge* differs from

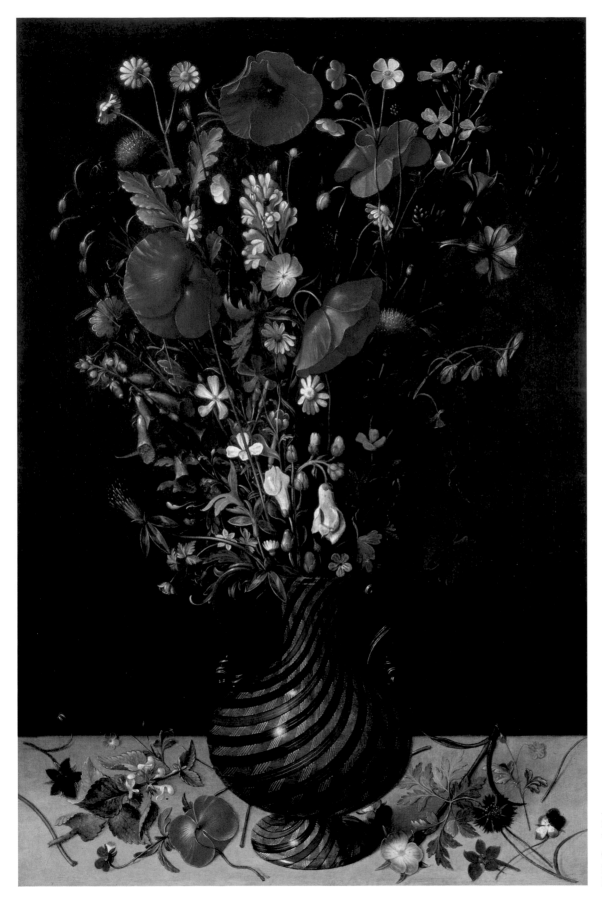

FIG. 14. Ludger tom Ring the Younger, *Vase of Wild Flowers on a Ledge* (cat. 23), c. 1565, oil on panel, Teresa Heinz (and the late Senator John Heinz)

such works. Nevertheless, as is character-istic of his other still lifes, the composition is entirely fanciful, for Tom Ring based the individual blossoms in the bouquet on his separate nature studies.[31]

Tom Ring's artistic innovations had little resonance beyond Münster and Braunschweig, the cities where he worked. Even though his images are far livelier than those in Dodoens' *Cruijdeboeck* (compare, for instance, the red poppies in figs. 13, 14), the impact of the herbal was far more lasting. Indeed, Dodoens' *Cruijdeboeck*—translated almost immedi-ately into French by his friend and con-temporary, the famous botanist Charles de L'Escluse, more commonly referred to as Carolus Clusius— quickly set a new standard for herbals throughout Europe.[32]

Florilegia

Even more important for the present study of flower imagery than the *Cruijde-boeck*, however, is a small book Dodoens first produced for the Plantin Press in Antwerp in 1568: *Florum et Coronariarum Odoratarumque Nonnullarum Herbarum Histo-ria*.[33] Devoted exclusively to odoriferous flowers, this book signifies the develop-ing fascination in Flanders with orna-mental plants, most of which had no known medicinal properties.[34] Many of these rare species, such as the tulip, recently imported from Turkey, or the sunflower, recently imported from Peru (fig. 15), were now gracing the extensive gardens of plant lovers like Pieter van Coudenberghe in Antwerp or Joannes Brancio in Mechelen. The importance of such gardens for the propagation of knowledge of plants is clear from Dodoens' account of the sunflower:

> They call this plant the "Sun of India" (or "Indian Sun") because it so resembles a sun surrounded by rays. We saw this plant in the delightful garden abundant with any variety of plants belonging to the excellent and worthy Joannes Brancio, a man who is very knowledgeable about the diversity of plants and whose gen-erosity and goodwill has resulted in a not inconsiderable number of flowers being added to this treatise which otherwise would not have been included. You may seek it in vain elsewhere, only to find it in his garden.[35]

Dodoens' small herbal ushered in a new form of botanical book, the flori-legium. Text in florilegia was summary, if present at all, for these beautifully con-ceived publications and manuscripts con-sisted almost exclusively of images of flowers, often beautiful or rare flowers that took pride of place in an individual's garden. Crispijn van de Passe the Younger (c. 1597–c. 1670), in the introduction to his influential florilegium *Hortus Floridus* (1614), acknowledges twenty-seven "lovers of flowers and herbs" from Utrecht, Amsterdam, Haarlem, and Leiden who provided him access to the rare blossoms depicted in his publica-

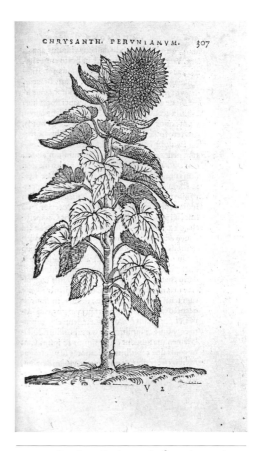

FIG. 15. Rembert Dodoens, *Sunflower* (cat. 53) from *Florum et Coronariarum Odoratarumque Non nullarum Herbarum Historia* (Antwerp, 2d edition), 1569, Dumbarton Oaks, Washington, Trustees for Harvard University

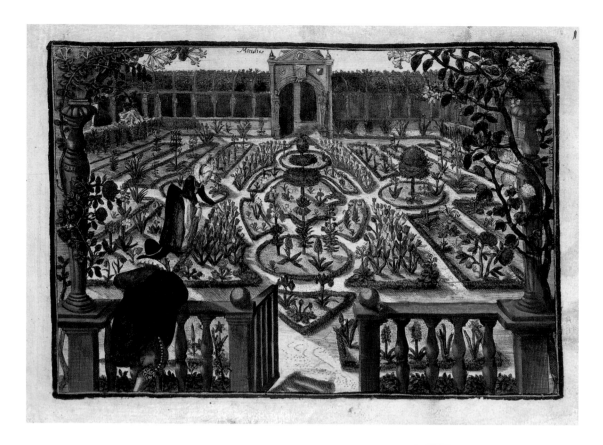

tion. Indeed, the patrons for some seventeenth-century florilegia were owners of great gardens who wanted a permanent record of the rare plants they had assembled (see figs. 48, 49).

Hortus Floridus contains a rare view of an ideal garden from the early seventeenth century (fig. 16). The private, enclosed space is divided into an ingenious, geometric pattern of small beds, each of which would have been bordered by low herbs and shrubs such as lavender, thyme, camomile, or box. These beds provided elegant frames for the choice plants in the collection: for example, a stunning Crown Imperial reigns in the circular bed at the center, while irises, tulips, and a sunflower occupy other areas of the garden. Van de Passe's garden represents an elaboration of the simpler geometric designs for rectangular compartments of small flower beds popular in the last decades of the six-

teenth century. Such a design is illustrated here in a delightful print of a garden of love by an unknown follower of Hans Vredeman de Vries (fig. 17).[36]

One of the first artists to create a florilegium was Jacques Le Moyne de Morgues (c. 1533–1588). A French Huguenot from Dieppe, he is best

known for the images of native peoples, flora, and fauna he made while on a French expedition to Florida during the mid-1560s.[37] In recent years, his name has also been attached to a number of remarkable watercolor and bodycolor studies of flowers and fruit, as well as to complete manuscripts consisting of deli-

cately rendered flowers. The pink damask rose facing a purple-and-blue wild pansy (heartsease), illustrated here, is from one of his most beautiful manuscripts, a small volume from the Garden Library, Dumbarton Oaks, consisting of sixteen miniatures painted on gold grounds (fig. 18).

This fascinating technique, unique among florilegia, indicates that Le Moyne de Morgues received his training as a miniaturist, perhaps in a French workshop that specialized in Books of Hours. Whatever his training, remarkable similarities exist between the techniques used in this manuscript and those in the *Warburg Hours* (see figs. 2, 3).[38] Indeed, the very choices of flowers in this manuscript—roses, pansies, violets, strawberry plants, and carnations—are precisely those found in Books of Hours, which suggests that this florilegium has at its core religious as well as botanical underpinnings.

None of the other extant manuscripts by Le Moyne de Morgues are executed on a gold ground, and his later works suggest that he became progressively more concerned with botanical accuracy. This interest culminated in the publication of a printed florilegium, *La Clef des champs* (London, 1586), which contained over ninety woodcut images of flowers, fruit, animals, and birds. Aside from allowing the reader to enjoy the "marvellous artifice of Nature," Le Moyne de Morgues recommended his publication as a model book for painters, engravers, jewelers, and embroiderers.[39]

Le Moyne de Morgues based the floral images in this publication on a large number of delicate and sensitively rendered watercolors made from life.[40] These watercolors, however, also had an extremely important afterlife, for they were apparently known, or owned by, one of the preeminent Dutch engravers and publishers, Crispijn van de Passe the

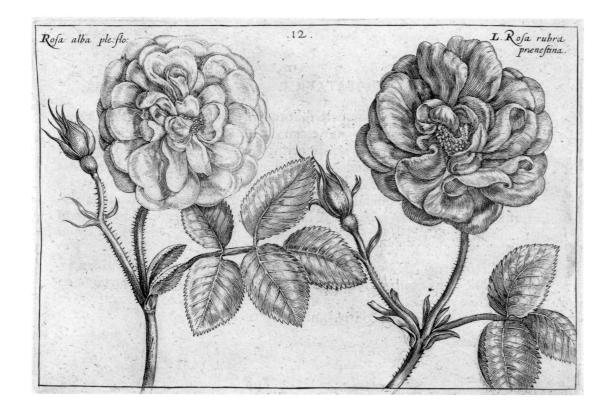

Elder (1564–1637). Van de Passe and his family, including sons and daughters he had trained to be engravers, established an important publishing house in Utrecht shortly after moving there in 1612.[41] Two years later, his talented son, the younger Crispijn, published *Hortus Floridus*, the most influential florilegium of the seventeenth century. Although he apparently engraved most of his flowers from life, a number of images engraved by another hand are based on watercolors by Le Moyne de Morgues (fig. 19).[42]

Van de Passe the Younger, following in the tradition of nature studies made by Dürer and his followers (see fig. 6),

established a new form of botanical illustration by depicting flowers growing in the soil, occasionally enlivening his scenes with insects and small animals (figs. 20, 21). To provide information about the bulb or root structure, he included uprooted or unburied bulbs resting on the soil. Although he and his collaborators carefully engraved leaves and blossoms to suggest nuances of texture and color, he also provided detailed instructions for coloring the images (fig. 21). Like Le Moyne de Morgues' *La Clef des champs*, Van de Passe's publication was widely consulted and used as a model book by artists and designers. Indeed,

a number of images in a copy of the book in the Folger Shakespeare Library (cat. 59) have been stippled for transfer.

Another popular early seventeenth-century florilegium, more elegant than Van de Passe's *Hortus Floridus*, was Johann Theodor de Bry's *Florilegium* (Amsterdam, 1612) (fig. 22). Its large scale allowed De Bry (1561–c.1623) to produce detailed engravings of flowers that are remarkable for their clarity of form and structure. While maintaining the flower's essential characteristics, De Bry often purified and idealized its form in his line engravings. This idealization reflects his underlying philosophical approach, which was

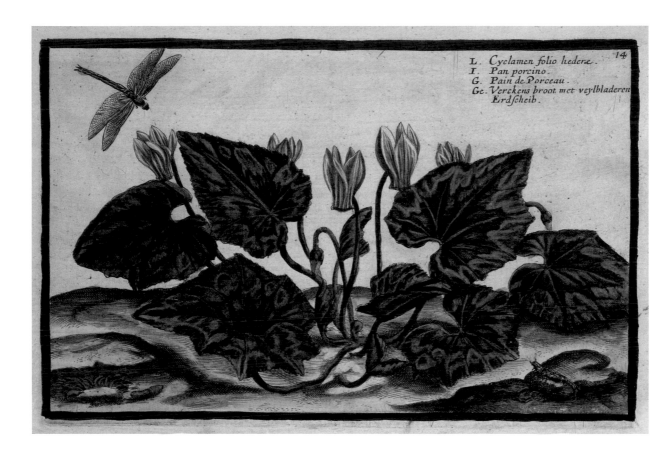

FIG. 20. Crispijn van
de Passe the Younger,
Cyclamen from *Hortus
Floridus*, (Arnhem)
1614, hand-colored,
Collection of
Mrs. Paul Mellon,
Upperville, Virginia

FIG. 21. Crispijn van
de Passe the Younger,
Crocus (cat. 57)
from *Hortus Floridus*
(Arnhem), 1614,
hand-colored,
Collection of
Mrs. Paul Mellon,
Upperville, Virginia

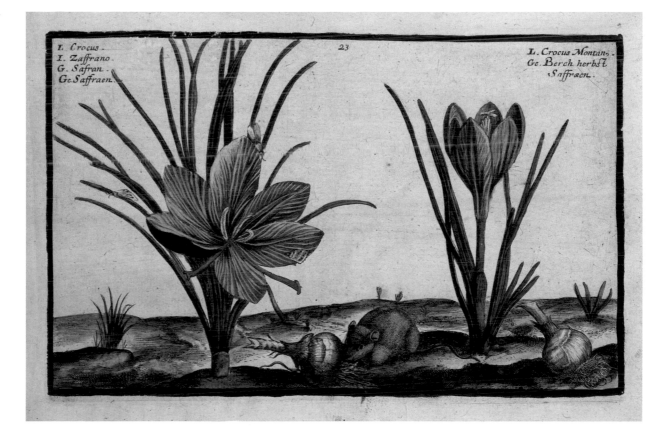

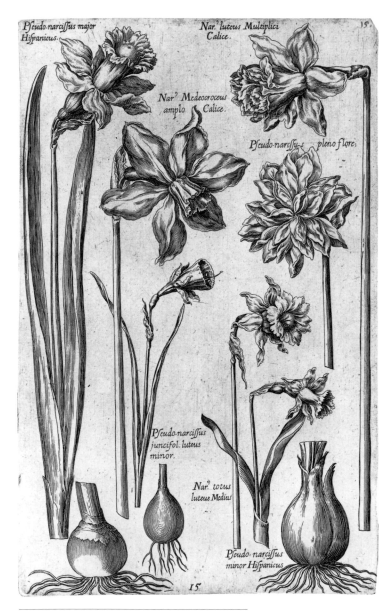

Fc*udo-narcissus major
Hispanicus.

Nar.⁹ luteus Multiplici
Calice.

15.

Nar⁹ Medeocroceus
amplo Calice.

Pseudo-narcissus pleno flore.

Pseudo-narcissus
juncifol. luteus
minor.

Nar⁹ totus
luteus Medius

Pseudo-narcissus
minor Hispanicus

15

FIG. 22. Johann Theodor de Bry, *Narcissi* (cat. 51)
from *Florilegium* (Amsterdam), 1612, The Folger
Shakespeare Library, Washington

founded on the belief that "Of all the things which spring from this earth, flowers are the most beautiful for their grace and dignity, just as man surpasses every other living thing in dignity of body and soul."[43] Although other artists may have sought to create more lifelike images than did De Bry, his appreciation of the grace and beauty of flowers was shared by all who came to depict them so carefully and lovingly in their drawings and paintings.

Joris Hoefnagel

The full story of seventeenth-century flower painting cannot be told without taking into consideration the work of the finest miniaturist of the late sixteenth century, Joris Hoefnagel (1542–1600). The first important phase of Hoefnagel's artistic career probably did not occur until the 1570s, when he studied in Antwerp with the miniaturist Hans Bol (1534–1593). In 1576 Hoefnagel fled Antwerp when it was sacked by Spanish soldiers and entered the court of Duke Albrecht V of Bavaria. By then Hoefnagel had developed a remarkable facility for painting illusionistic flowers and insects in the margins of manuscripts.[44] When illustrating the empty margins of the *Book of Hours of Philip of Cleves*, he continued the practice of earlier painters of Books of Hours from the Ghent-Bruges school and depicted realistic flowers illusionistically pinned onto the leaves of the manuscript.[45]

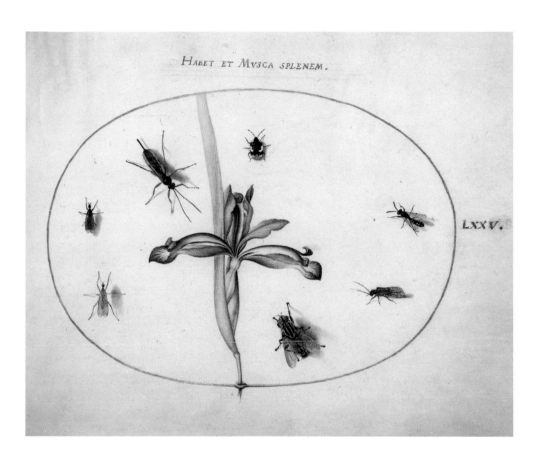

HABET ET MVSCA SPLENEM.

LXXV.

There in Munich, in the midst of the duke's renowned *Kunstkammer*, Hoefnagel utilized the pictorial heritage of the Ghent-Bruges school of painting to create one of the most remarkable compendia of natural history ever made, a four-volume manuscript, *The Four Elements*.[46] Hoefnagel organized his encyclopedic presentation of thousands of living creatures around the traditional framework of the four elements. He carefully rendered each of the birds, animals, fish, insects, and flowers in watercolor and bodycolor, and sensitively arranged them within oval fields (fig. 23). Latin inscriptions derived from the Bible, the *Adages* of Erasmus, proverbs, and classical authors accompany each page and provide a moralizing commentary to the images portrayed. In its fusion of art, science, and emblematics, *The Four Elements* summarizes much about late sixteenth-century attitudes toward the description and discovery of the world.

Hoefnagel concentrated on this project for over two decades, until it was acquired for a great sum by his eventual patron, the Emperor Rudolf II. Its pages are filled with images drawn from life, but also with those copied from the works of naturalists, particularly Conrad Gesner, and artists, among them Albrecht Dürer and Hans Bol. Dürer's nature studies, much admired at the courts in Munich, Vienna, and Prague, profoundly affected Hoefnagel's style. One particularly striking example is this delicate image of a blue iris from volume I of *The Four Elements, Ignis*. On this and many other pages in this volume, Hoefnagel whimsically played with the spatial illusionism of his scene. While the insects cast shadows on the page, the iris seemingly grows vertically, its stem attached to the bottom of the gold oval enframement and its leaf disappearing behind the oval at the top.

During the early 1590s Hoefnagel lived in Frankfurt, a dynamic city filled with emigrés—humanists, artists, naturalists, publishers—from the war-torn Southern Netherlands.[47] Hoefnagel quickly joined this circle, which included Carolus Clusius. This botanist had in his possession illustrations Le Moyne de Morgues had made during his Florida expedition, and probably also owned other nature studies by the French artist; these he certainly would have shown to Hoefnagel.[48]

Perhaps because he found himself in the midst of this flourishing publishing

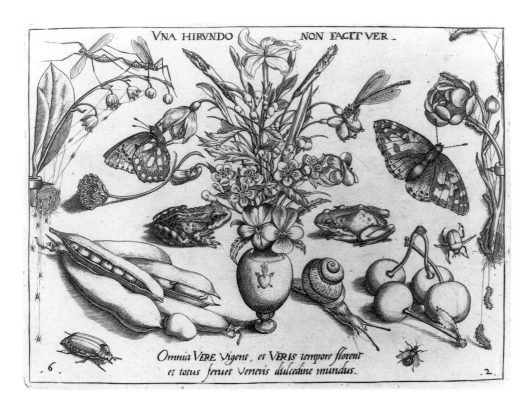

UNA HIRUNDO NON FACIT VER.

Omnia VERE vigent, et VERIS tempore florent
et totus fervet Veneris dulcedine mundus.

.6. .2.

bolic references: love (the flaming heart on the vase); birth and rebirth (the frogs who have slept through the winter and the butterflies who have metamorphosed from caterpillars); and the transience of earthly beauty (the spiderweb encompassing the lily of the valley).

Of course, in the context of this examination of the origins of Dutch and Flemish flower painting, the presence of this spectacular vase of spring flowers at the center of the composition is as intriguing as the image's complex emblematic symbolism. This arrangement indicates that Hoefnagel not only rendered individual blossoms with great sensitivity, such as the iris in *Ignis*, but also delighted in creating tightly packed, realistic floral bouquets.

FIG. 24. Jacob Hoefnagel after Joris Hoefnagel, *Emblematic Page* (cat. 56) from *Archetypa Studiaque Patris Georgii Hoefnagelii* (Frankfurt), 1592, National Gallery of Art, Gift of Mrs. Lessing J. Rosenwald

center, Hoefnagel, in collaboration with his son Jacob, decided to publish *Archetypa*, a series of emblematic prints based on his miniatures of plants, insects, and small animals.[49] *Archetypa*'s fascinating subject matter, as well as the engraved images that allowed for much more detail than possible with traditional woodcuts, ensured its appeal. It quickly became a major pictorial source for artists and artisans, among them Jacques de Gheyn II (1565–1629) and Roelandt Savery.[50]

A characteristically fascinating leaf from *Archetypa* depicts a vase of spring flowers surrounded by frogs, beetles, a snail, butterflies, dragonflies, peas, and cherries (fig. 24). Attached to the frame at the left is a lily of the valley covered with spiders and their web; at the right, a globe flower supports caterpillars building their cocoons. The emblematic meaning of this symmetrical assemblage of flowers, animals, and insects is provided by the Latin text below, praising the beauty of spring when the whole world glows with the sweetness of Venus, and by the motto above, warning that spring is but a fleeting moment in life.[51] The image itself is filled with sym-

Pioneers of Early Seventeenth-Century Flower Painting

The widespread fascination of sixteenth-century Dutch and Flemish botanists, gardeners, and artists in the cultivation, propagation, display, and accurate depiction of individual plants and blossoms underlies one of the most remarkable genres of painting to emerge at about the turn of the century: the representation of flower bouquets artfully arranged in a decorative glass or vase. Almost simultaneously, and seemingly independently, painters in various artistic centers throughout The Netherlands, not only in Antwerp, but also in Middelburg, Amsterdam, and Leiden, began to create

imaginative displays of floral bouquets. These pioneers—Jacques de Gheyn II, Roelandt Savery, Ambrosius Bosschaert the Elder, Christoffel van den Berghe (active by 1617–1642), and Jan Brueghel the Elder—created images that established the stylistic bases for the extraordinary tradition of Dutch and Flemish flower painting that evolved during the Golden Age of the seventeenth century.

Many questions surround the origins of flower painting. How is it that these masters learned so rapidly to depict accurately the delicacy of petals, the textures of leaves, and the organic relationships of the plants' parts? Who gave them access to these flowers and taught them botany? Who persuaded them that there was a ready market for paintings of floral bouquets, and what, indeed, was this market? And, finally, were these paintings admired solely as aesthetic objects or did they also contain symbolic meanings that enlarged their appeal to collectors?

Ludger tom Ring's vases of flowers, painted in the 1560s (see fig. 14), had little or no impact on the history of Netherlandish flower painting, probably because his works remained in Münster and Braunschweig. Depictions of flower bouquets in vases, however, were familiar to Dutch and Flemish painters through prints and title pages of herbals. Most of

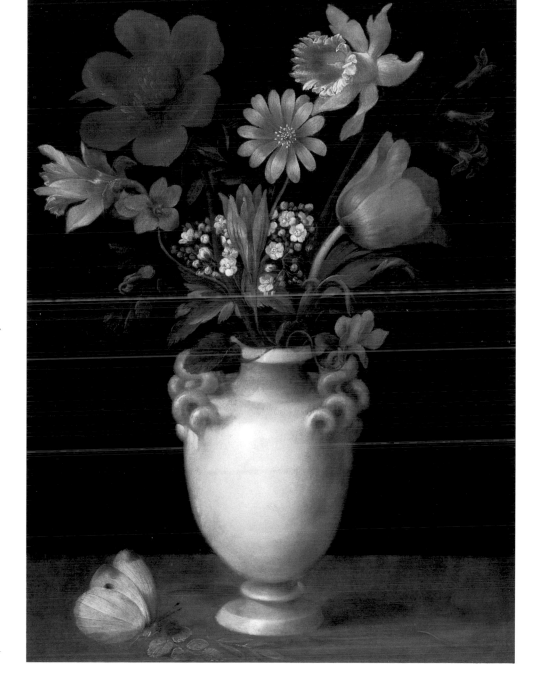

FIG. 25. Joris Hoefnagel, *Flower Still Life with Alabaster Vase* (cat. 17), c. 1595, oil on copper, Teresa Heinz (and the late Senator John Heinz)

these were quite stylized and, as with the vase of flowers in *Archetypa* (see fig. 24), depicted densely packed, symmetrical arrangements, surmounted by one large blossom, usually a tulip.

In various ways, Dutch and Flemish artists who pioneered this new genre of painting sought to go beyond these slightly stilted engraved images by imbuing their flower still lifes with a breath of life.[52] Through precise rendering of plants, naturalistic coloring, and imaginative arrangements, they sought to create the impression of images painted "naer het leven," even when they included blossoms from different seasons of the year.

These painters believed that a diverse array of differently shaped and colored flowers made for a visually interesting bouquet, an idea implicit in Karel van Mander's 1604 poem on the fundamentals of artistic creation:

> Nature is beautiful through variety;
> this one can see when the earth,
> blooming with almost a thousand colors,
> stands showing its worth to the starry
> throne of Heaven.[53]

While artists relied upon careful observation of God's wonders to render individual blossoms, they used their imagination to create variety within their bouquets. Indeed, the artist's ability to create effects that Nature could not equal was often extolled in contemporary thought.[54]

One of the earliest, and most intriguing, painted flower bouquets is an oil on copper from the late 1590s by Joris Hoefnagel (fig. 25).[55] Although no other comparable works are known by Hoefnagel, the carefully modeled spring flowers—among them a red anemone, lavender tulip, hyacinth, crocus, and yellow daffodils—have a rhythmic flow reminiscent of flowers in his manuscript images, and the elegant alabaster vase resembles one in his *Archetypa* (see fig. 24).

The connections between the painted and engraved images, however, also illuminate the differences between them. The informal arrangement of spring flowers in the painting is far more lifelike than the symmetrical bouquet in *Archetypa*, a conceptual change indicating that the artist was more intent upon replicating nature in his painting than he was in his emblematic engraving. Since many of the flowers in Hoefnagel's painting are exotics that had only recently been imported into The Netherlands, memorializing such rare specimens, and showing their brilliant colors, may have been one of the stimuli for the emergence of the flower still life.[56]

Jacques de Gheyn II

It is entirely possible that this generation of painters was drawn into the field of flower painting by botanists who engaged artists to record specimens for their own research. The most important of such connections existed between

Carolus Clusius, who had moved from Frankfurt to Leiden in 1593 to lay out the famous botanical garden at the university, and Jacques de Gheyn II, who had moved to Leiden from Haarlem in 1595. Their contact is documented not only through the portrait De Gheyn made of Clusius in 1600, but also through the title page the artist designed for Clusius' magnum opus, *Rariorum Plantarum Historia* (Antwerp, 1601).[57] De Gheyn also engraved the plan of the *Hortus Botanicus* that Clusius designed for Leiden. Clusius' presence in Leiden almost certainly persuaded De Gheyn to expand his artistic repertoire from primarily imaginative figural drawings and engravings to include careful nature studies of flowers, insects, and small animals.

Throughout his long and illustrious career, Clusius had discovered numerous exotic species of plants on travels to distant lands, many of which he incorporated into the *Hortus Botanicus* in Leiden. There he propagated and popularized not only the tulip, but also other species from the Middle East, among them daffodils, Crown Imperials, and hyacinths. Clusius approached botanical studies very seriously, filling his publications with careful descriptions of plants to complement the woodcut illustrations. As with Dodoens, Clusius often based these images on watercolor drawings he had commissioned from artists or had received as gifts from other collectors and botanists. This wealthy and inveterate collector of botanical imagery almost

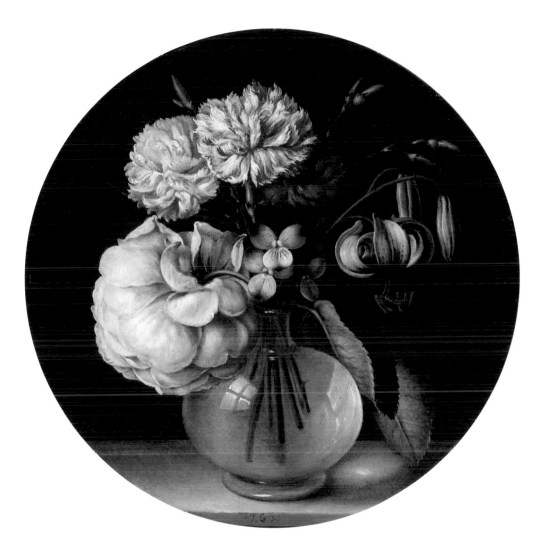

made oil paintings of floral bouquets when he began to take an interest in learning about color. Van Mander wrote that De Gheyn's first still life, "a small flowerpot from life," was "very precisely done and amazing as a first effort."[59] This painting was well received, for Van Mander noted that it was soon purchased by the Amsterdam "art-lover," Hendrick van Os, which indicates that a ready market among collectors already existed for this new genre of painting.[60] Indeed, Van Mander also related that a larger bouquet of flowers subsequently painted, "with much patience and precision," was acquired by no less a connoisseur than Emperor Rudolf II.

One of De Gheyn's finest achievements is an album of flower-and-insect watercolor drawings on parchment, which Rudolf II also acquired.[61] De Gheyn's album (executed 1600–1604, now in the Institut Néerlandais, Paris) has the character of a florilegium, and probably depicts flowers growing in Clusius' *Hortus Botanicus* in Leiden.[62] Aside from providing De Gheyn with flowers, Clusius may also have furnished him with artistic models to emulate, probably botanical illustrations by Hoefnagel and Le Moyne de Morgues.[63] De Gheyn's album also includes one study of flowers, informally arranged in an alabaster vase, quite similar in style to Hoefnagel's painting (see fig. 25).

An unusually intimate painting by De Gheyn dating from this period, 1602–1604, is a sensitively conceived arrange-

certainly possessed drawings by his friend Joris Hoefnagel, as well as *Archetypa*, which Hoefnagel had published in Frankfurt while Clusius resided there. He probably also owned botanical drawings by Le Moyne de Morgues.[58]

To judge from Van Mander's intriguing account of De Gheyn's artistic career in *Het Schilder-boeck* (1604), the artist first

ment of flowers in a bulbous glass vase (fig. 26). De Gheyn effectively adapted his tightly massed composition of flowers, including a large pink rose, carnations, pansies, and a Turk's Cap Lily, to fill the circular copper support. He almost certainly composed his bouquet from drawings he had made from life; the exotic Turk's Cap Lily, for example, also appears in the Paris album.[64] As with many early still-life painters, De Gheyn attached disproportionately large and weighty blossoms to short stems, which are visible through the greenish blue tonalities of the glass vase. Nevertheless, he sought to give his blossoms a naturalistic character by modeling them with light, which strikes this bouquet from the left. A painted reflection of the window on the surface of the glass vase enhances the illusion of reality, as does the diffused light refracted onto the stone ledge to the right of the vase.

Like Hoefnagel's small bouquet of flowers in an alabaster vase (fig. 25) and De Gheyn's own watercolor in the Paris album, this small roundel is marked by an asymmetrical informality that stands apart from other still lifes of the period. Nevertheless, De Gheyn's roundel, like virtually all still-life paintings from this period, is characterized by detailed and precise renderings of individual blossoms and leaves. In this respect, flower still lifes differ fundamentally from early seventeenth-century religious and mythological paintings, landscapes, and merry company scenes, in which artists rarely, if ever, sought to render natural forms in such an accurate fashion.

Roelandt Savery

The differences in approach between still lifes and these other genres of painting are particularly evident in the work of Roelandt Savery. Although Savery painted landscapes with dramatic light effects and exaggerated, distorted rock formations, he was as intent as any other still-life painter of the period to record individual blossoms in his floral bouquets. He was so successful that specialists today can identify each and every flower and animal in his complex and varied arrangements.[65]

This intriguing figure's importance in the development of flower painting has often been underestimated. Born in Kortrijk, Savery lived and studied in Amsterdam with his older brother Jacques from about 1591 until 1603, when the latter died from the plague. From his brother, Roelandt learned to paint both still lifes and Paradise scenes filled with exotic animals and plants—two specialties that appealed greatly to Rudolf II. The emperor seems to have invited Roelandt to work for him in Prague, for Savery moved there in 1603 or 1604 and stayed until 1615, when he returned to Amsterdam. But it was Savery's next move that was to prove significant for the story of the development of seventeenth-century Dutch flower painting. In 1618 he settled in Utrecht, where he influ-enced Ambrosius Bosschaert and Balthasar van der Ast, both of whom had moved to the city the previous year. Savery lived in Utrecht for the rest of his life and enjoyed a successful career, though he died in bankruptcy.

Savery's remarkable floral bouquet, dated 1603, is the earliest securely dated still life by any Dutch or Flemish artist (fig. 27). Whether Savery painted it in Amsterdam or Prague is not known, but its fascinating combination of naturalism and exoticism is precisely the type of image that appealed to Rudolf II.[66] Savery placed his arrangement, including a flame red-and-yellow tulip, a blue iris, roses, columbine, and a fritillaria, in a stone niche, as though he wished to contrast the rugged texture of the stone with the delicacy of the flowers, leaves, and buds—whose deep colors and soft forms imbue them with a velvety sheen. The bouquet fills the niche, its peripheral forms enveloped in the atmospheric recesses of the shaded background. The niche enhances the sense of illusionism Savery wished to create, an effect he reinforced not only by illuminating the still life from the side, but also by overlapping leaves and flowers, including the rare and expensive tulip.

The stone niche is a fascinating conceit, for it gives great weight and solemnity to the image, as though announcing that the bouquet has significance beyond the purely decorative. Although Savery provides no specific indication of symbolic meaning for his bouquet, the very

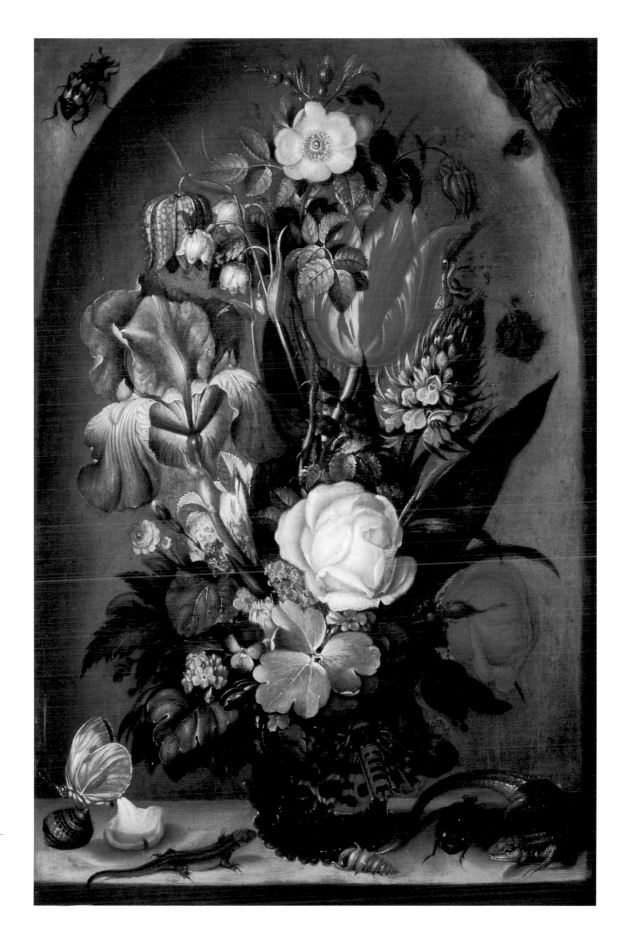

FIG. 27. Roelandt Savery, *Flowers in a Roemer* (cat. 24), 1603, oil on copper, Anonymous lender in honor of Frank and Janina Petschek

inclusion of blossoms from different seasons, rare shells, and an array of small insects and animals—moths, lizards, a beetle, a bee—indicates that he approached this image allegorically as well as naturalistically.

This imaginative representation of the multiplicity and beauty of God's creations parallels depictions of Paradise that Savery and his older brother Jacques created during the early years of the seventeenth century. The iconic presentation of this bouquet serves much the same purpose as does the biblical narrative in the Paradise scenes: it makes one reflect upon the very reasons for the painting's existence. Indeed, Savery's compilation—with its self-conscious array of flowers, shells, and insects—has more in common with Jacob Hoefnagel's emblematic image of a bouquet of flowers in *Archetypa* (see fig. 24) than with De Gheyn's small, informal roundel (see fig. 26).

Ambrosius Bosschaert the Elder

Whereas Savery's flower paintings appear somber and, perhaps because of the presence of lizards and beetles, slightly ominous, a far different mood pervades the flower still lifes of his slightly younger contemporary, Ambrosius Bosschaert, who began his artistic career in Middelburg, a prosperous trading center and capital of Zeeland.[67] Much of Middelburg's wealth came from the Dutch East India Company, for it was the location of one of the company's two largest

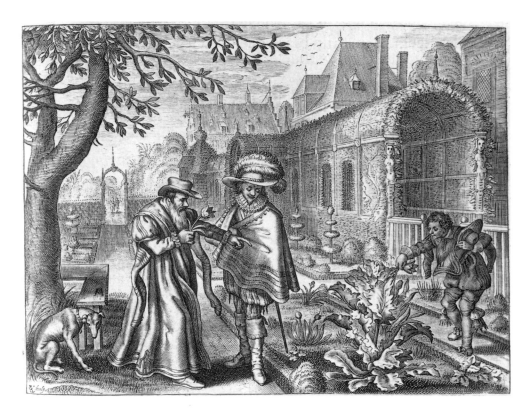

FIG. 28. Adriaen Pietersz. van de Venne, *Ex minimis patet ipse Deus* (*God is revealed in the smallest work of his creation*) (cat. 61) from *Zeevsche nachtegael* (Middelburg), 1623, National Gallery of Art, Library

regional offices (Amsterdam being the other). As a center for the import of exotic goods from foreign lands, Middelburg was also renowned for its botanical gardens. Jacob Cats, for example, describes with obvious wonder the garden of a friend from Middelburg:

> There she has many fruits from divers
> foreign lands,
> A multitude of plants from divers distant
> strands,
> And unknown, nameless blooms.[68]

The most important Middelburg garden was that established in the 1590s by the great botanist Matthias Lobelius, a

friend and colleague of Dodoens and Clusius who served as the city's doctor during the latter decades of the sixteenth century.[69] Lobelius' herb garden, which was transformed into a flower garden after he left for England in 1602, was later owned by Adriaen van de Venne (1589–1662) and his brother.[70]

This garden probably inspired Van de Venne's delightful engraving of a scholar using one of his choice plants to show a worldly young man how God is visible

in the smallest of his creations (fig. 28).[71] The lively, expressive contours of the scholar's costume evoke the excitement and enthusiasm of botanists and collectors over the discovery of every new plant, for each one revealed more of God's unfathomable wisdom and ingenuity. Indeed, since the Middle Ages, man has believed that God reveals his wisdom not only in his first book, the Bible, but also in his second "book," creation, that is, the earth with all its flora and fauna.

Bosschaert probably began his career depicting rare and exotic flowers in Middelburg gardens.[72] It has been plausibly suggested that he was the artist a Middelburg gardener commissioned in 1597 to make an image of a fritillaria for the botanist Carolus Clusius.[73] Whether or not Bosschaert was associated with this undertaking, he certainly composed his paintings with the aid of such drawings. Identical flowers, sometimes depicted in reverse, appear in different compositions.[74] One example of this working procedure is evident in an exquisite still life from 1612–1614 (fig. 29), in which a number of flowers, including the white rose, red-and-white striped anemone, columbine, lily of the valley, yellow crocus, and pansy, appear elsewhere.[75] Bosschaert also included identical blossoms in two related bouquets of roses (figs. 30, 31).

FIG. 29. Ambrosius Bosschaert the Elder, *Still Life with Flowers* (cat. 8), 1612–1614, oil on copper, Teresa Heinz (and the late Senator John Heinz)

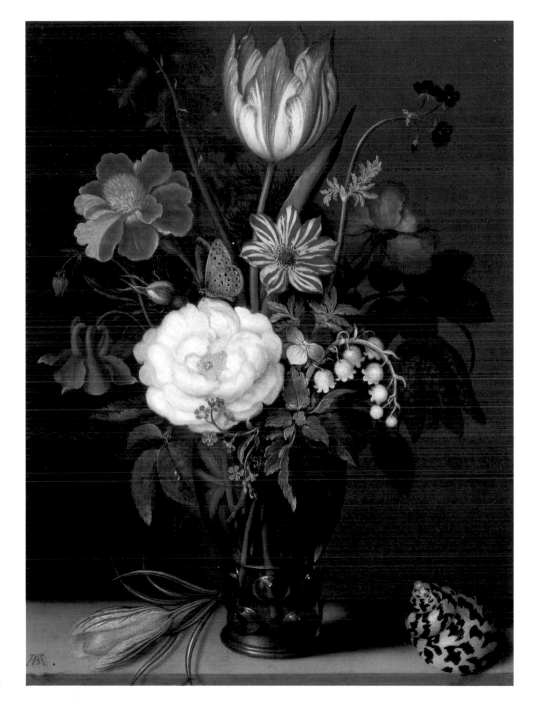

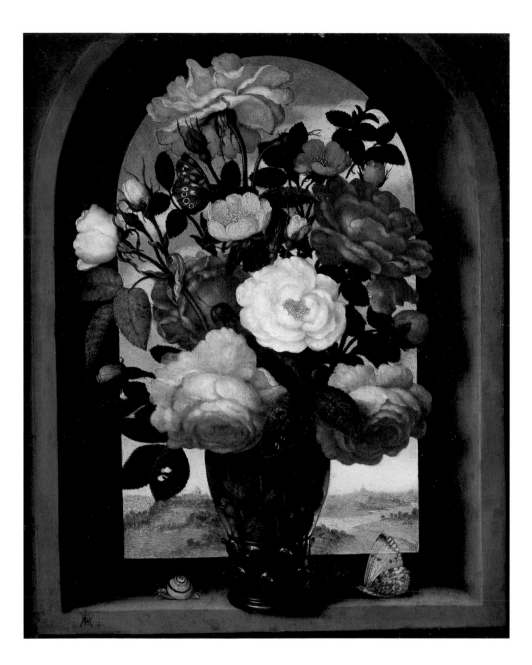

FIG. 30. Ambrosius Bosschaert the Elder, *Roses in an Arched Window* (cat. 9), 1618–1619, oil on copper, Private Collection, Holland

Bosschaert infused his works with a sense of joy. He had an unerring compositional awareness, and delighted in combining a range of flowers with different colors and shapes to create a pleasing and uplifting visual experience. He also enjoyed the illusionism of painting flower stems through the translucent surface of glass. In many respects, Bosschaert's style had a primitive simplicity, for he arranged his blossoms symmetrically, surmounting the whole with a large and spectacular blossom, generally a striped tulip. He retained the integrity of individual blossoms by arranging them to avoid overlapping forms. Finally, he used light less to model his flowers than to illuminate them and bring out the brilliance of their colors.

Bosschaert, who left Middelburg in 1615, lived in Utrecht until he relocated to Breda in 1619. As is evident in two remarkable paintings of roses from 1618–1619 (figs. 30, 31), Bosschaert's style evolved significantly during his Utrecht and Breda years, perhaps owing to the influence of Crispijn van de Passe's *Hortus Floridus* (1614) and the still lifes of Roelandt Savery, who had moved to Utrecht in 1618. During this period Bosschaert's bouquets became more naturalistic, as he painted petals with softer, more velvety textures. While he continued to compose symmetrical bouquets surmounted by a single large flower, he arranged his flowers more informally, often overlapping individual blossoms. Bosschaert also began to introduce insects, dewdrops,

and deformities of leaves, all of which enhanced the naturalistic character of his bouquets.

Even as his style evolved, Bosschaert continued to follow his well-established working procedure throughout his life. Identical rose blossoms appear in each of these two bouquets of roses, which he also arranged according to a similar compositional schema.[76] Yet subtle variations between the individual floral elements—for example, the placement of the deformations in the leaves or of the water droplets—demonstrate how he adjusted his models from one painting to another.

The interweaving of artificiality and naturalism in the artist's work is particularly evident in the open stone niches he introduced as settings for his flower bouquets during his Utrecht period. On the one hand, Bosschaert used these niches to enhance a sense of illusionism by depicting shadows of leaves and blossoms along their illuminated inner edges and by situating vases and blossoms so that they protrude into the viewer's space. On the other hand, like Savery (see fig. 27), Bosschaert utilized the niche motif to transform these flower still lifes into iconic images meant to be honored and admired. By juxtaposing these bouquets against open sky or an imaginative landscape, Bosschaert created a setting for them that was unrelated to everyday reality. Thus, while his bouquets contained naturalistic flowers and insects, his setting signaled that they con-

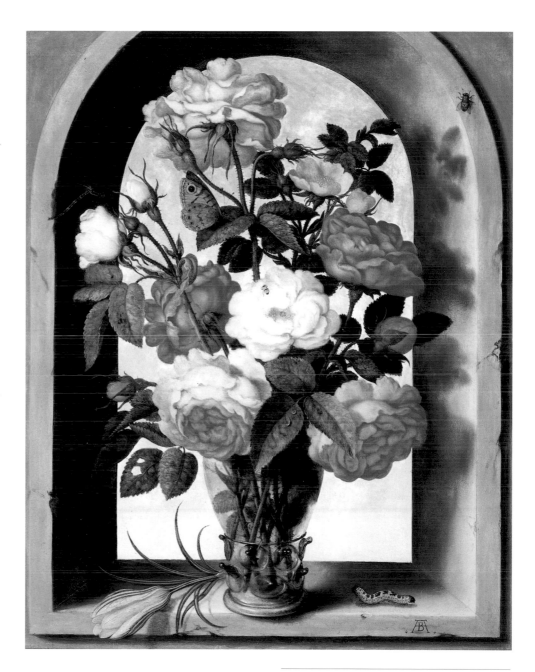

FIG. 31. Ambrosius Bosschaert the Elder, *Vase of Roses in a Window* (cat. 10), 1618–1619, oil on copper, Private Collection, Boston

41

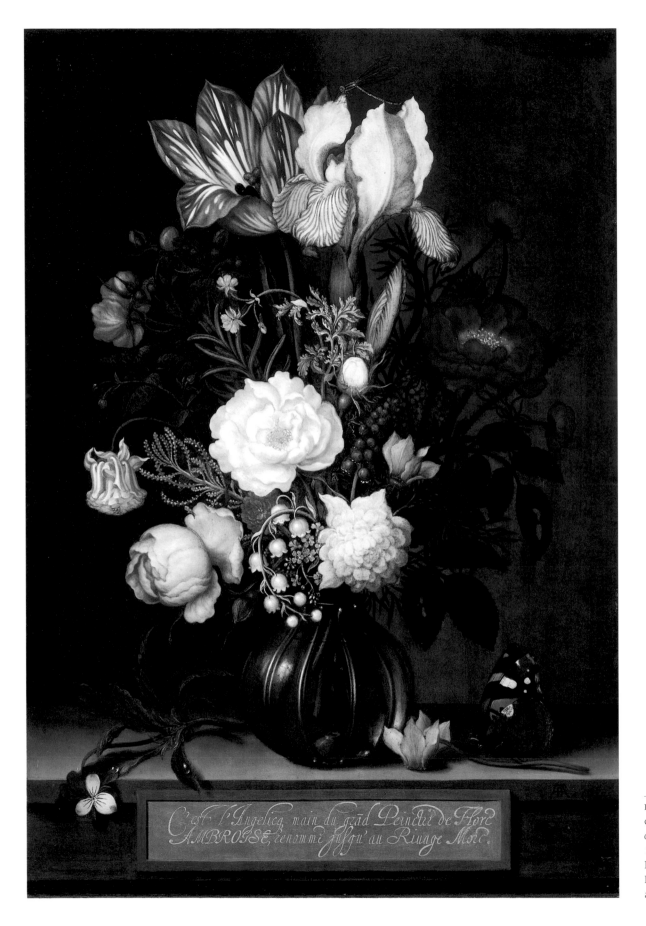

FIG. 32. Ambrosius Boss-
chaert the Elder, *Bouquet
of Flowers in a Glass Vase* (cat.
11), 1621, oil on copper,
National Gallery of Art,
Patrons' Permanent Fund
and New Century Fund

tained an abstract or allegorical message, one almost certainly analogous to that expressed in Van de Venne's contemporary print (see fig. 28): even the smallest blossom serves as a reminder of the greatness of God's creation.

Here, however, one enters into a fascinating, and vexing, area of interpretation, for how specific can one get in reading such paintings symbolically. In seventeenth-century Dutch society, which was deeply imbued with the idea that God's presence was found in all of creation, the very act of painting and drawing realistically was viewed as rendering him honor. Moreover, certain flowers, such as the rose, lily, and violet, were traditionally associated with specific religious symbolism certainly known to Bosschaert and his contemporaries.

The extent to which artists included flowers for their inherent symbolism is difficult to determine, particularly when so little is known about the patronage of these works. It is unlikely that all elements in most Dutch and Flemish flower bouquets are infused with symbolic meaning, whether they be flowers, butterflies, or snails; in some still lifes, however, artists probably intended a broad religious symbolism. In *Roses in an Arched Window* (fig. 30) and *Vase of Roses in a Window* (fig. 31), for example, Bosschaert focused upon a flower with strong Christian symbolism. Indeed, these red, pink, and white roses are remarkably similar to those surrounding *The Annunciation* miniature of the *Warburg Hours*

(see fig. 2). Bosschaert may also have intended the insects in these paintings to serve as both symbolic and naturalistic elements: the caterpillar and butterfly traditionally relate to the idea of death and resurrection, while the snail and butterfly suggest the earthly and the spiritual.[77]

The enhanced naturalism of Bosschaert's late style is nowhere more evident than in his last known work, *Bouquet of Flowers in a Glass Vase*, signed and dated 1621, the year of his death (fig. 32). Even though this exquisite image includes a wide variety of species, among them a yellow iris, a red-and-white striped tulip, roses, a blue and white columbine, fritillaria, grape hyacinth, lily of the valley, and a sprig of rosemary, the flowers and herbs form a coherent, closely integrated ensemble. Bosschaert also introduced subtle tonal gradations in the background to reinforce the sense of light flooding the image.

Bouquet of Flowers in a Glass Vase occupies a special place in Bosschaert's oeuvre, for its inscription, filling an illusionistic plaque attached to the table's front, offers one of the most moving testaments to the artist's enormous reputation at the time of his death: "C'est l'Angelicq main du grād Peindre de Flore AMBROSE, renommé jusqu'au Riuage Mort" (It is the angelic hand of the great painter of flowers, Ambrosius, renowned even to the banks of death).[78]

The Bosschaert Dynasty

Ambrosius Bosschaert and Roelandt Savery established the parameters of seventeenth-century Dutch flower painting. Their styles, though individual, were similar enough that numerous artists drew inspiration from them both. One of the most fascinating of these is Christoffel van den Berghe, about whom little is known except that he lived in Middelburg from at least 1619 to 1628.[79] Although only five of his still lifes and a few landscapes are yet extant, he was a gifted master who was well regarded in his day.

Most scholars assume that Van den Berghe studied with Bosschaert because the younger artist's precise manner of painting resembles the older master's style. However, the density and profusion of flowers in his masterpiece (fig. 33), dated 1617, share more stylistic characteristics with Roelandt Savery's paintings than with Bosschaert's (see fig. 29). Like Savery in his 1603 still life (see fig. 27), Van den Berghe placed his bouquet in a slightly battered stone niche enlivened by shells, Chinese porcelain cups, bugs, and numerous butterflies.[80] Despite this animated composition, Van den Berghe's flowers, particularly his tulips, are rather stiff, a quality that gives his painting a charming naiveté. Van den Berghe first registered with the Saint Luke's Guild in Middelburg in 1619, two years after he painted this work. Thus, it is entirely possible that he trained elsewhere—perhaps Amsterdam, where he could have

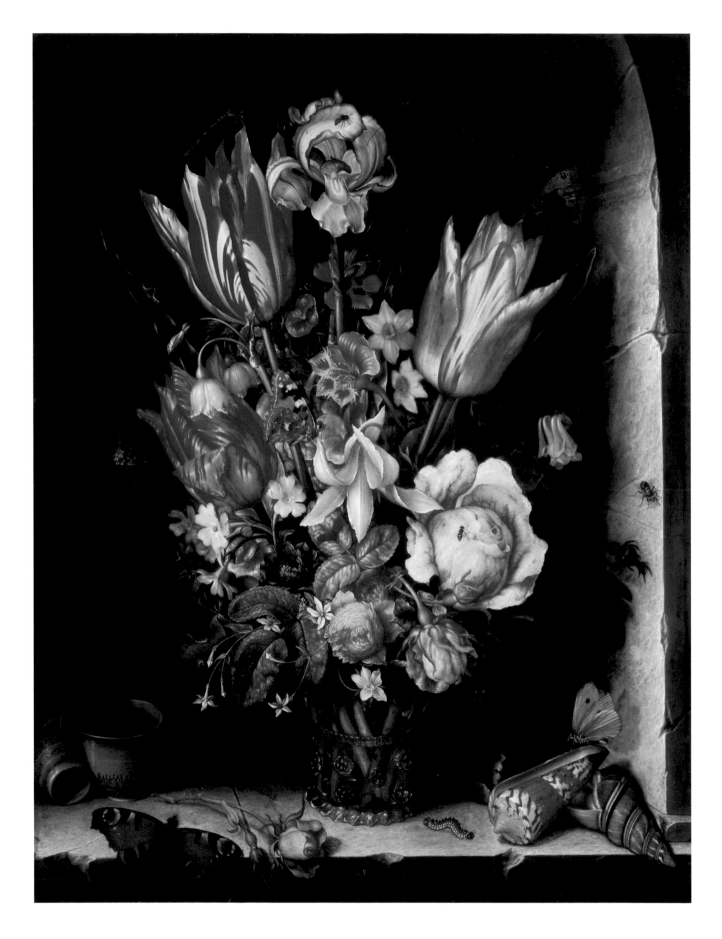

known Savery after the latter's return from Prague in 1615.

An artist who truly merged Bosschaert's and Savery's traditions was Balthasar van der Ast, whose work is the embodiment of Dutch and Flemish flower painting from the first half of the seventeenth century (see page 13). Van der Ast lived successively in Middelburg, where he learned his craft in the studio of his brother-in-law Ambrosius Bosschaert the Elder; Utrecht, where his style was influenced by the dynamic still lifes of Roelandt Savery; and Delft, where he painted during the height of tulipmania in the mid-to-late 1630s.

Van der Ast admired the delicacy and grace of flowers, but also their rarity and exoticism. He often arranged his bouquets in Wan-li vases (see fig. 1), as though this expensive imported china was the most appropriate type of vessel for beautiful and costly flowers.[01] To reinforce the sense of wonder engendered by these images, Van der Ast frequently included rare shells from distant seas, which he lovingly rendered to capture their varied textures, colors, and shapes. Regarded as treasures by collectors both large and small, shells, like rare bulbs, were highly valued and sought after. Van der Ast also wanted to create a lively image, made "naer het leven," and thus delighted in animating his still lifes with lizards, snails, grasshoppers, spiders, butterflies, dragonflies—in short, with small creatures of all types.

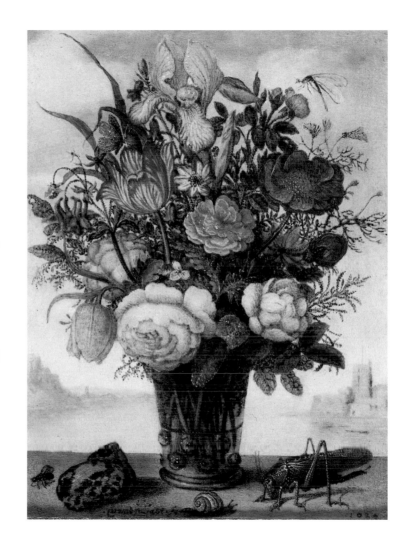

FIG. 34. Balthasar van der Ast, *Bouquet on a Ledge with Landscape Vista* (cat. 4), 1624, oil on copper, The Henry H. Weldon Collection

FIG. 33 (opposite page). Christoffel van den Berghe, *Still Life with Flowers in a Vase* (cat. 7), 1617, oil on copper, Philadelphia Museum of Art, John G. Johnson Collection

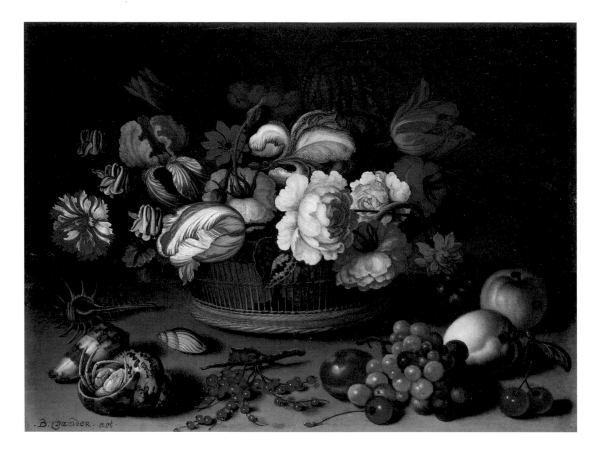

FIG. 35. Balthasar van der Ast, *Basket of Flowers* (cat. 2), c. 1622, oil on panel, National Gallery of Art, Gift of Mrs. Paul Mellon

FIG. 36. Balthasar van der Ast, *Basket of Fruit* (cat. 3), c. 1622, oil on panel, National Gallery of Art, Gift of Mrs. Paul Mellon

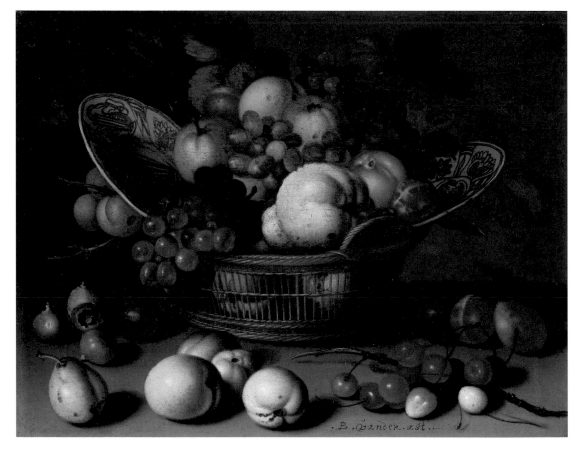

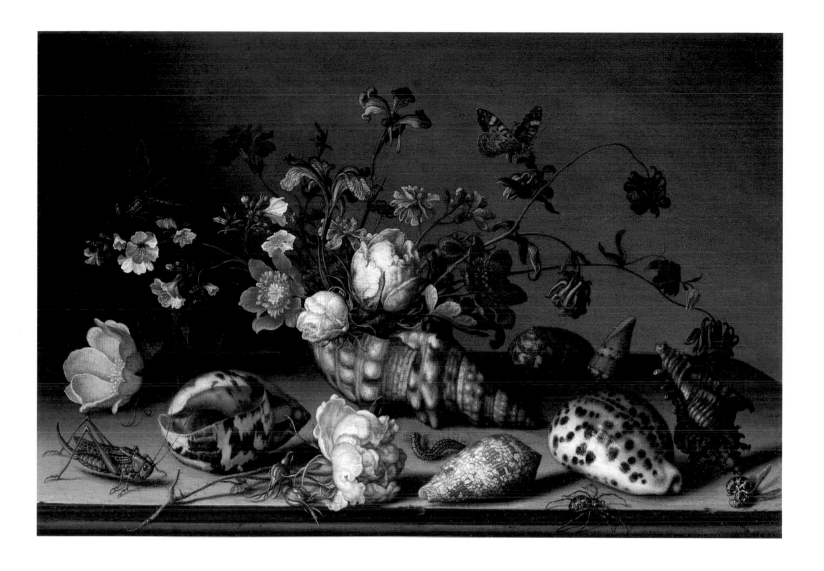

FIG. 37. Balthasar van der Ast, *Still Life of Flowers, Shells, and Insects on a Stone Ledge* (cat. 6), mid-1630s, oil on panel, Pieter C.W.M. Dreesmann

One of Van der Ast's most charming still lifes is this intimately scaled *Bouquet on a Ledge with Landscape Vista*, signed and dated 1624 (fig. 34). This small oil on copper is the only work by Van der Ast to include a fanciful landscape vista. One wonders if he painted it in conscious emulation of his master, Ambrosius Bosschaert, as a tribute to his memory, perhaps like the inscription in the Washington painting (see fig. 32). The densely compact arrangement of flowers resembles Bosschaert's bouquets more than it

does Van der Ast's own loose and flowing arrangements during the mid-1620s (see fig. 1).

Van der Ast was highly esteemed during his lifetime. Two of his paintings (probably figs. 35, 36) were listed as "a basket with fruit and a basket with flowers," in the 1632 inventory of the collection of the prince of Orange, Frederik Hendrik, and his wife Amalia van Solms.[82] These pendant paintings complement each other thematically as well as compositionally. The combination of fruit, flowers, and rare shells creates a sense of the abundance and beauty of God's creation. However, following an organizing principle previously encoun-

tered in the work of Joris Hoefnagel, Van der Ast conceived these works to represent the four elements. Fine china, here represented by precious Wan-li plates, symbolized fire; fruit signified earth; flowers, air; and shells, water.[83]

Van der Ast's individuality as an artist only became apparent in the mid-1620s, when he began to open his compositional arrangements by allowing flowers to reach out into space, as in *Flowers in a Wan-li Vase* (see fig. 1). His airy and light-filled mature style, which extended into his Delft period of the 1630s, produced some of the most rhythmic and imaginative still lifes in all of Dutch art. An outstanding example is *Still Life of Flowers,*

Shells, and Insects on a Stone Ledge (fig. 37), a tour de force notable for its conceit of using a rare shell to hold an elegant spray of flowers. Surrounding this central motif, Van der Ast created a circular arrangement of shells, flowers, and insects, an artificial construct that he unified through the overarching tendrils of the iris, columbine, and bellflowers (*Campanula*). Van der Ast's light not only illuminates and models individual compositional elements, but also enlivens their forms. Finally, the painting demonstrates the artist's extraordinary ability to allow air to circulate in and around his forms, a characteristic that, more than any other, brings life to his works.

Jan Brueghel the Elder

Jan Brueghel was a famous artist when in 1604 he visited the court of Rudolf II in Prague. The second son of Pieter Brueghel the Elder (c. 1525–1569), Jan, who trained in Antwerp, had already traveled extensively and visited, among other artistic centers, Cologne, Rome, Naples, and Milan. In Milan he had met his lifelong patron Cardinal Federico Borromeo, who considered Brueghel's works "the lightness of nature itself."[84] And in Antwerp the Saint Luke's Guild had elected him dean in 1602. The following year, Brueghel's charmed life had been confronted with tragedy, for his wife Elizabeth had died while giving birth to Paschasia, a daughter who later would marry the painter Jan van Kessel

the Elder (1626–1679) (see fig. 56). It was perhaps partially for this reason that Brueghel undertook his trip to Prague.

Although Brueghel stayed in Prague only a short while, he must have had an opportunity to see some of the splendid nature studies in Rudolf's collection, perhaps even the ones the emperor had acquired that very year from Jacques de Gheyn. He also may have met Roelandt Savery, who had recently arrived from Amsterdam. One thing, however, is certain: he saw a painted miniature or a pattern book by Joris Hoefnagel that inspired him to paint a small copper depicting a spray of rosebuds and a mouse. When Brueghel sent this small painting to Borromeo in July 1605, the cardinal commented, "no one has ever seen the like in oils, painted so painstakingly and in such detail."[85]

Brueghel returned to Antwerp filled with the idea of painting flower still lifes —large, imposing still lifes bursting with flowers of all types. In a letter of 1606 he described one such bouquet that he was painting for the cardinal:

> [It] will succeed admirably: not only because it is painted from life but also because of the beauty and rarity of various flowers which are unknown and have never been seen here before: I therefore went to Brussels to portray a few flowers from life which cannot be seen in Antwerp.[86]

Brueghel's painting for Borromeo, which still exists, contains over one hundred different floral varieties, including eight species of tulip, five types of iris, and at least nine forms of narcissus.[87]

In 1608 Brueghel sent the cardinal a smaller bouquet, which was so successful that the artist soon began making comparably intimate flower paintings for other collectors. One such work, *Flowers in a Glass Vase* (fig. 38), exhibits Brueghel's spirited style—the blossoms almost seem to come alive through the sensitivity of his touch. In this bouquet of tulips, carnations, narcissi, poppy anemones, forget-me-nots, larkspurs, and a pink rose, he captured not only the rhythm of leaves and blossoms, but also the translucency of petals and nuances of colors that few other artists could match. He delighted, as well, in suggesting the transparency of the glass vase and in capturing the sparkle of light animating the rosettes and ridges along its surface.

Brueghel's letters to Cardinal Borromeo provide rare insights into the working method of this early seventeenth-century flower specialist.[88] They indicate not only that he made trips to distant cities to find rare and unusual blossoms, but also that he waited entire seasons for flowers to grow. Brueghel stressed that he painted rare and beautiful flowers directly from nature without

FIG. 38. Jan Brueghel the Elder, *Flowers in a Glass Vase* (cat. 12), c. 1608, oil on panel, Private Collection

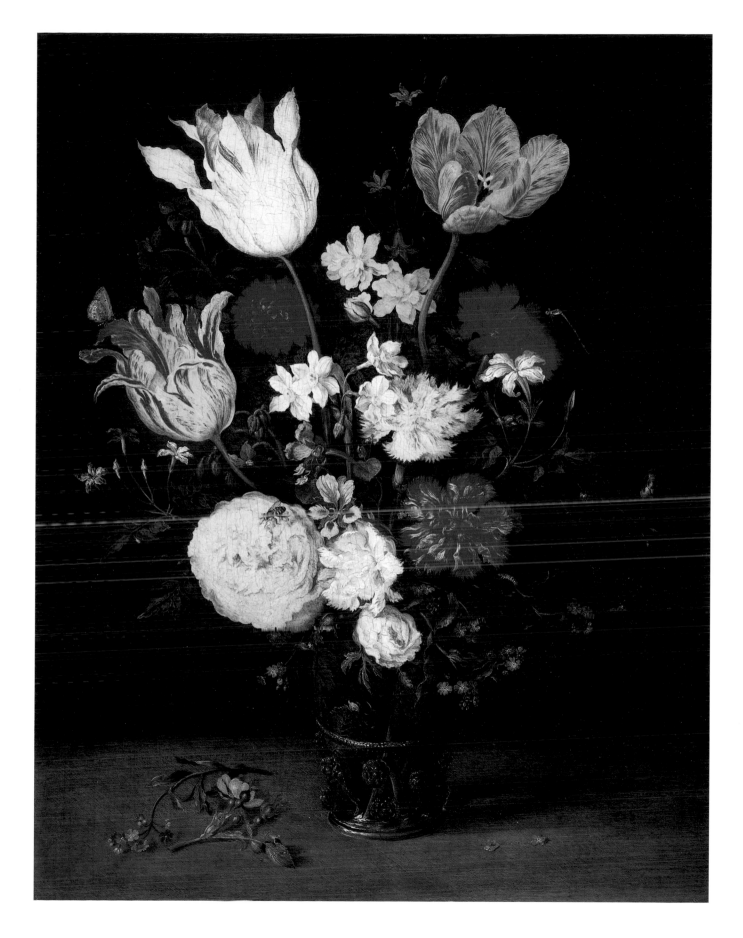

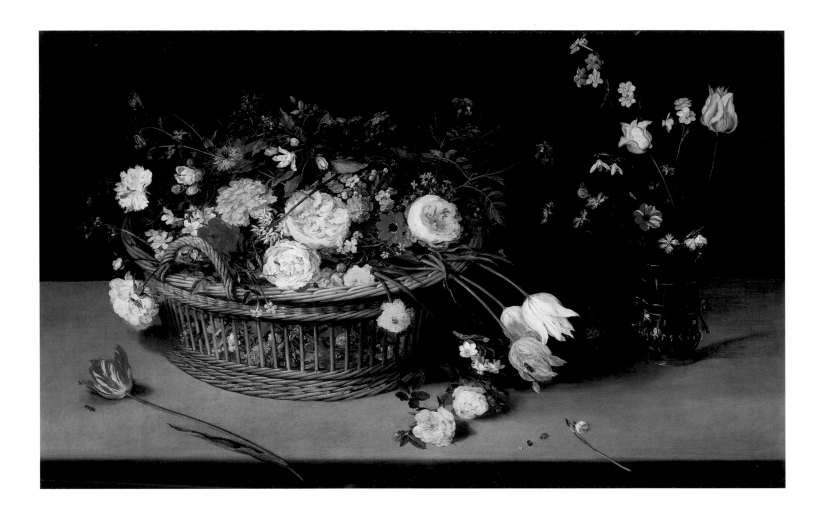

the benefit of preliminary drawings or oil sketches, and that he relied solely upon his discrimination when arranging his compositions. One can imagine that the artist worked simultaneously on various flower bouquets. In fact, while a number of compositions are related to *Flowers in a Glass Vase*, they consist of slightly different arrangements, with subtly varied blossoms and flower species. In contrast to Bosschaert, Brueghel only occasionally depicted identical blossoms in more than one work.

A Basket of Mixed Flowers and a Vase of Flowers (fig. 39) juxtaposes the natural splendor of a wicker basket overflowing with cut flowers, including tulips, buttercups, roses, anemones, and columbine, with a Venetian-style glass containing discreetly arranged tulips, buttercups, and other delicate field flowers. This combination of elements emphasizes the freshness of the cut flowers, for it suggests that the vase has just been filled with blossoms recently brought from the garden. Brueghel's sensitive handling of paint, which ranges from thick impastos to thin glazes, creates delicate and effervescent forms imbued with extraordinary naturalness.

This profusion of blossoms, which no gardener could have garnered during any one season of the year, reflected a fundamental theological concept that was held by many, including Brueghel's patron, Cardinal Borromeo.[89] They believed that the blessings of God's creation were to be found in the extraordinary richness and beauty of the natural world. Thus, while accuracy was important in recording God's individual creations—flowers, insects, and shells—an imaginative melding of beautiful flowers from different seasons of the year celebrated the greatness of his munificence.

The Idea of Earthly Transience
Inevitably, the fullness of Brueghel's artistic vision also touches upon the fundamental concept of *Ars longa, vita brevis*. God's wonders on earth were boundless, but the beauty of flowers, like life itself,

is transient. As Borromeo himself remarked, these painted flowers will continue to blossom long after nature's flowers have withered and died.

Flowers and flower paintings occupied a fascinating role in contemporary appraisals of the relationship of objects in the natural world to God and his divinity. On the one hand, the beauty and variety of flowers symbolized the richness of nature, God's creation; on the other hand, contemporary moralizing texts and numerous passages in the Bible equated flowers with the concept of transience. The most famous of these texts is Psalm 103, verses 15–16:

> As for man, his days are as
> grass: as a flower of the field, so he
> flourisheth.
> For the wind passeth over it,
> and it is gone; and the place thereof
> shall know it no more.

As the discoveries of the new marvels of nature multiplied, seventeenth-century men, both Catholics and Calvinists, remained acutely conscious of the transitoriness of everything on earth. They still held to the ancient concept of the universe that God (gods), the stars, planets, sun, and moon were eternal, but that everything on earth was temporal. One of the most powerful statements of the transitoriness of earthly life was the Old Testament Book of Ecclesiastes, which preached that the pursuit of earthly pleasures, riches, and prestige was futile and

vain. All were vanities.[90] However, the core of the Christian message was that man, through Christ, could aspire to eternal salvation. It behooved him not to be diverted from eternal values by the earthly, temporal marvels of God's creation. This fundamental concept lies behind the sentiment inscribed on one of Brueghel's flower bouquets: "Look upon this flower which appears so fair, and fades so swiftly in the strong light of the sun. Mark God's word: only it flourishes eternally. For the rest, the world is naught."[91]

The idea of transience is not expressly indicated in most flower paintings from the beginning of the seventeenth century. Nevertheless, in the midst of these celebrations of God's bounty, artists began to interject subtle reminders of the ephemerality of nature. In fact, some of the very elements that made flower bouquets more lifelike, such as deformed leaves (see figs. 30, 31) or earth-bound insects like caterpillars, worms, and grasshoppers (see figs. 33, 34), could be viewed as indicators of life's inevitable decay. Such subtle reminders of transience in flower bouquets have to be seen within the context of expressly conceived *vanitas* images, in which flowers are brought together with skulls and hourglasses, and even admonishing texts, as warnings about the transience of life (see fig. 56).[92]

Daniel Seghers and Jan Philips van Thielen
Cardinal Borromeo was an extraordinarily gifted man, as passionate about art as he was about the Catholic faith. He also understood the power and impact of images on man's spiritual belief. As with many of his generation, he had been greatly troubled by the iconoclastic attacks, particularly on venerated images of the Virgin, that had occurred during the 1560s and 1580s in The Netherlands. By 1600 Catholic theologians throughout Europe had placed much emphasis in reinstating the importance of sacred images of the Virgin, not only by adorning them with new crowns and jewels but also by draping them with garlands of flowers.[93]

After receiving Brueghel's remarkable flower paintings in 1606 and 1608, the cardinal recognized that Brueghel's ability to simulate real blossoms could be utilized for religious purposes. Thus, as early as 1608, Borromeo asked Brueghel to paint a garland of flowers around an image of the Madonna.[94] Brueghel enthusiastically agreed and created a work that drew upon the pictorial tradition of illuminated manuscripts, in which flowers surround religious scenes (see fig. 2), and upon the actual practice of draping flowers around venerated images of the Virgin. Brueghel's garland painting for Borromeo contains just such a sacred image: a Madonna and child, executed on silver by Hendrick van Balen (1575–1632), inserted into the middle of the panel.

FIG. 40. Daniel Seghers
and Cornelis Schut the
Elder, *Garland of Flowers with
a Cartouche* (cat. 25),
c. 1630, oil on panel,
Teresa Heinz (and the
late Senator John Heinz)

FIG. 41 (opposite page).
Jan Philips van Thielen,
*Roses and Tulips and Jasmine in
a Glass with a Dragonfly and
a Butterfly* (cat. 26), 1650s,
oil on panel, National
Gallery of Art, Gift of
Mrs. Paul Mellon

Although Brueghel, in collaboration with Van Balen and other figure painters, first developed this new genre of still-life painting, the artist most renowned for depicting garlands of rare and beautiful flowers was Brueghel's most important student, Daniel Seghers (fig. 40). Seghers, who converted to Catholicism and entered the Jesuit order in 1615, was a devoutly religious man. He painted extensively for the Jesuits, who often presented Seghers' works as tokens of honor and esteem to rulers and dignitaries throughout Europe. Indeed, to judge from the accolades Constantijn Huygens and Cornelis de Bie heaped upon his work, the incredible illusionism of Seghers' flowers elicited awe and admiration throughout Europe.[95]

Seghers' paintings of garlands, like Brueghel's, were collaborative efforts, as, for example, with this beautiful depiction of a garland around an Annunciation scene, which Seghers executed together with Cornelis Schut the Elder (1597–1655), a prolific religious painter who worked in Antwerp in the style of Rubens.[96] Seghers hung the garland of flowers from illusionistically rendered blue ribbons supporting the painted frame of the Annunciation. In contrast to Brueghel, who created a circular arrangement of flowers around the central religious image, Seghers concentrated his flowers into two areas, those crowning the Annunciation and those forming a semicircular enframement around the other three sides.

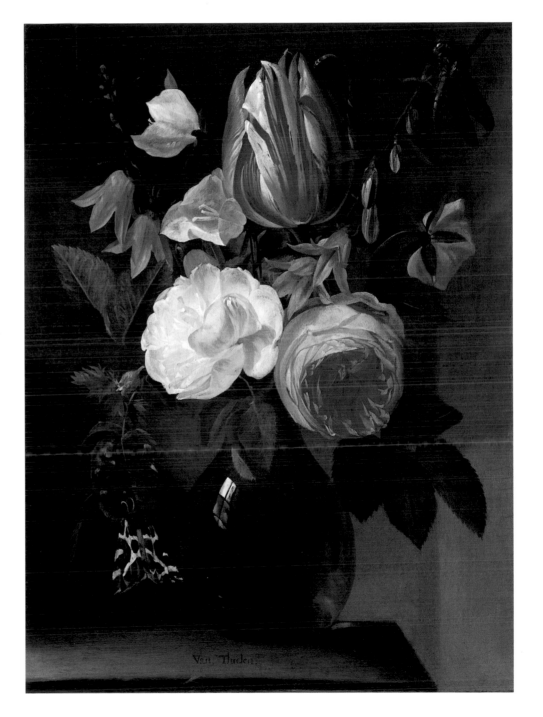

Seghers used his crisp, yet elegant style to render an extremely wide range of cultivated garden flowers, from expensive striped tulips, roses, and anemones, to narcissi, irises, and fritillarias. He had a great gift for harmoniously arranging differently colored and shaped flowers to create a vibrant and joyous surround for the miraculous event transpiring in Schut's image. Indeed, it is fascinating to compare the different moods established in the dynamic relationship between the floral motifs and religious images in this work and those in the Annunciation scene in the *Warburg Hours*, in which the flowers and figures are far more restrained and contemplative (see fig. 2).

Jan Philips van Thielen (1618–1667) learned the art of flower painting from Seghers, with whom he studied shortly before entering the Antwerp Saint Luke's Guild in 1641/1642. Although Van Thielen also painted a number of garlands surrounding religious images, he was at his best in small paintings that include only a few blossoms (fig. 41). In this tabletop still life, he focused his carefully considered compositional arrangement around three large blossoms, a large red-and-white striped tulip at its apex and pink and white roses situated near the rim of the tear-shaped glass vase. Interspersed on diagonal axes between these blossoms are a variety of smaller purple, blue, and white flowers, including two violet bellflowers (*Campanula*), three white tussock bellflowers (*Campanula carpatica*),

and a deep blue cornflower. Van Thielen's technique for modeling blossoms with planes of color is more abstract and less descriptive than that of his master, but it effectively captures the fresh diaphanous character of individual petals.

The painting's appealing simplicity and intimacy serve as reminders that most Dutch and Flemish flower still lifes were painted for the privacy of the home. Van Thielen's compositional restraint is reinforced by his sensitivity toward color harmony and by the clarity with which he conveyed the geometrical structure of the individual flowers. As in this work, he generally represented short-stemmed, emerging blossoms with a minimum of overlapping, avoiding the elegantly interwoven compositions containing long-stemmed blossoms past their prime preferred by most of his contemporaries.

Tulipmania and Seventeenth-Century Portraits of Flowers

The artists who specialized in flower paintings were exceedingly well paid. Emperors, princes, cardinals, and other wealthy collectors sought their services, while poets and critics eulogized their achievements. Much of their success was due to their own artistic abilities, for they did create remarkably illusionistic paintings that seem able to deceive insects or to produce the very odors of real blossoms. Nevertheless, these artists also owed part of their economic success to the fascination flowers held for their

contemporaries. It is most unlikely that Ambrosius Bosschaert, Roelandt Savery, Jan Brueghel the Elder, or Daniel Seghers would have received such vast sums for their works had not flowers themselves been so enormously valued. One can imagine the quandary of Cardinal Borromeo when Brueghel wrote: "Under the flowers I have painted a jewel with coins....It is up to your honour to judge whether or not flowers surpass gold and jewels."[97]

Today, the idea that the rarity of flowers depicted in a still life might affect the painting's value is difficult to comprehend, but such considerations were important for seventeenth-century collectors. On the other hand, one can scarcely imagine trading a house for a tulip bulb, but that, of course, happened at the height of speculation during tulipmania in the mid-to-late 1630s.[98] The variety of shapes and colors of tulips fascinated everyone, and just as speculators were willing to pay enormous sums for new hybrids, so were collectors eager to see them represented in works of art. And Dutch and Flemish artists, whether strongly influenced by such economic factors or not, clearly developed a great affinity for depicting the tulip. This exotic flower appears in virtually all painted bouquets during the first four decades of the seventeenth century.

The importance of tulips in Dutch horticulture is nowhere more evident than in the appearance of *tulpenboeken*, tulip catalogues illustrated with paintings

FIGS. 42–44. Jacob Marrel, *Admiral d'Hollande* (cat. 36), *Title Page* (cat. 40), and *Geel en Root van Leven* (cat. 37) from *Tulpenboek*, 1642, bodycolor on paper, Collection of Mrs. Paul Mellon, Upperville, Virginia

of individual tulips. These books were probably commissioned by floriculturists who wanted to provide a visual catalogue of the dizzying array of blossoms they could offer for sale. Such catalogues served a real purpose because buyers bid on bulbs, and thus needed some indication about the type of blossom they might expect to see.[99]

One of the artists most active in producing these books was Jacob Marrel (1614–1681), who prided himself in depicting tulips "naar 't leven" (figs. 42, 44).[100] These two sheets come from one of the most magnificent of his tulip books, dated 1642, which contains a title

page (fig. 43) and no fewer than ninety-five separate specimens, each identified in elegant calligraphic lettering.[101] The tulips' names, which range from *Admiral d'Hollande* to *Geel en Root van Leven* (Yellow and Red of Life), reflect a great sense of pride and national identification, qualities Marrel captured in his carefully objective, yet slightly idealized images.

Marrel's *Tulpenboek* is also of great historical interest because it contains a list of the prices paid for the tulips during the tulipmania of 1635, 1636, and 1637, a period Marrel described as "de op-en ondergang van flora" (the rise and fall of flora). Although unbridled speculation

FIGS. 50–51. Jan Withoos, *Cyclamen* (left) and *Morning Glory* (right, cat. 48) from *A Collection of Flowers*, c. 1670, bodycolor on vellum, Collection of Mrs. Paul Mellon, Upperville, Virginia

This exquisite manuscript illustrates 235 different plant species—all sumptuously colored and decoratively arranged on vellum sheets. As in the page depicting a narcissus, red snapdragon, and jonquils and in that representing a fritillaria, Johnny-jump-ups, and vinca, De Geest (c. 1639–1699) often combined different species, much as they would have been planted in contemporary gardens. De Geest's compositions are fundamentally formal and symmetrical, and he remains true to his primary goal of providing botanically accurate portraits of individual flowers. Nevertheless, his gentle overlappings of forms and sensitivity to the rhythmic flow of the various species create an unusually lifelike depiction of a garden environment.

De Geest, whose uncle was Rembrandt van Rijn (1606–1669), probably learned the art of flower painting in Antwerp, where he studied with Erasmus Quellinus II. By the 1660s De Geest had returned to his native Leeuwarden, where he executed this florilegium.[106] He may have been commissioned to paint this volume by Count Willem Frederik of Nassau, *stadhouder* of the Province of Friesland, who had constructed a magnificent garden on one of Leeuwarden's ramparts. De Geest's creative arrangements of flowers resemble a florilegium painted in 1654 by Johann Walther for a German relative of the *stadhouder*, Count Johann of Nassau-Idstein.[107]

Another artist who specialized in elegant and rhythmic images of flowers was Jan Withoos (1648–c. 1685) (figs. 50, 51), who belonged to a family renowned for its botanical illustrations. Flower and insect studies were made not only by his father Matthias (1627–1703), with whom he studied, but also by his sister Alida (1659/1660–1730) and his brothers Pieter and Frans (1657–1705). Although Jan is the least documented of the four artistic siblings, his three-volume collection of watercolors, consisting of 263 studies of flowers and plants on large vellum pages, is one of the most magnificent florilegia of the late seventeenth century. The patron for this exceptional work was probably the important Amsterdam bibliophile Paulo van Uchelen, who was a passionate collector of illustrated books and manuscripts. Withoos'

three-volume manuscript, with its beautiful gilt-leather binding made by Van Uchelen's binder Albert Magnus, was featured in the 1703 auction of Van Uchelen's "splendid collection of art and books."[108]

Not only did Withoos have a remarkable sensitivity to the unique characteristics of each flower, he had a genius for placing his images on the white expanse of his page. For example, Withoos filled his sheet when depicting the flowing

tendrils of a morning glory, while he relegated low-growing Johnny-jump-ups to the bottom half of the page. To provide more information about the cyclamen plant, Withoos depicted it growing from a small mound of earth, a pictorial device first utilized by Crispijn van de Passe the Younger in 1614 (see fig. 20). While the pictorial concept is similar, a comparison between Van de Passe's tightly compacted plant and Withoos' delicate and ethereal forms reveals the

FIG. 52. Pieter Withoos, *Fritillaria meleagris* (cat. 42), 1683, gouache on paper, Abrams Collection, Boston

FIG. 53. Antoni Henstenburgh, *Five Tulips* (cat. 31), early-to-mid 18th century, watercolor and bodycolor on vellum, Abrams Collection, Boston

contrasting artistic sensitivities of flower specialists at either end of the seventeenth century.

At the time of the French invasion of The Netherlands in 1672, Matthias Withoos moved with his family to Hoorn because this prosperous maritime city in North Holland was far from the disruptive forces of the French armies.[109] It was there, in Hoorn, that Pieter Withoos executed this fluidly rhythmic drawing of a fritillaria (fig. 52), one of a series of watercolors of flowers from the garden of Louis de Marle of Haarlem.[110] Hoorn was also the home of other artists who made scientifically precise watercolor flora and fauna on vellum: Johannes Bronkhorst (1648–1727) and his student Herman Henstenburgh (1667–1726). Henstenburgh's son, Antoni, continued this tradition throughout the first half of the eighteenth century, creating exuberant sheets such as this study of tulips (fig. 53). Here, in a manner far different from that of Jacob Marrel (see figs. 42, 44), every stem, leaf, and petal of these magnificent blossoms seems alive with movement. Antoni executed this sheet with a special kind of watercolor, devised by his father, which was renowned for being so bright and robust that it rivaled oils.[111]

Willem van Aelst and Jan Davidsz. de Heem
The stylistic changes evident in the work of Withoos and Henstenburgh in the late seventeenth and early eighteenth centuries first made their appearance in the work of two outstanding and innovative painters, Willem van Aelst (1626–1683) and Jan Davidsz. de Heem (1606–1683/1684). Although Van Aelst and De Heem came upon their stylistic and thematic ideas independently, each created dynamic, even exhilarating, compositions that fully engage the viewer emotionally and, perhaps, spiritually. As is evident in Van Aelst's *Vanitas Flower Still Life* (fig. 54) and De Heem's *Vase of Flowers* (fig. 55), each was a master craftsman, capable of rendering the delicacy of petals, the translucency of glass, or the wetness of dewdrops on leaves. Each understood the power of light to help create illusionistic effects that could bring a painting to life.

Van Aelst, who was born and raised in Delft, joined the city's Saint Luke's Guild in 1643.[112] Shortly thereafter he left for France and Italy, where he assisted the Dutch still-life painter Otto Marseus van Schrieck (1619/1620–1678) while the latter worked for the grand duke of Tuscany, Ferdinand II de' Medici, who had extensive botanical gardens. Since Van Aelst's mature flower paintings have little direct relationship to earlier Dutch still-life traditions, he most likely developed his elegant and courtly style while working for the grand duke, who presented the artist with a gold medal

and chain for his service. After returning to The Netherlands in 1656, Van Aelst achieved tremendous success. Not only was he extremely well paid for his works, but his artistic genius was eulogized by the poet Jan Vos.[113]

De Heem, on the other hand, was fully immersed in Dutch and Flemish pictorial traditions from the very beginning of his career. Born in Utrecht, he began his training there with his father shortly after the appearance of Van de Passe's *Hortus Floridus*, and just as Roelandt Savery, Ambrosius Bosschaert, and Balthasar van der Ast were defining the very essence of flower painting. When the family moved to Leiden in 1626, De Heem began painting in the manner of the Leiden painter David Bailly (1584–1657) and created a number of monochrome still lifes with *vanitas* themes that include books, writing and smoking implements, skulls, and hourglasses.

After De Heem moved to Antwerp in 1635, he transformed his subject matter and style once again. Inspired by Daniel Seghers' compositional sensitivity and elegant rendering of blossoms, De Heem began painting flower bouquets, many of which incorporated religious symbolism. He also began creating elaborate banquet scenes, filled with colorful drapery, flowers, fruit, and lobsters, as well as luxurious pieces of silver, porcelain, and glass. He continued to produce such works after returning to Utrecht in 1649, thereby transforming the character of both Dutch and Flemish still-life painting.

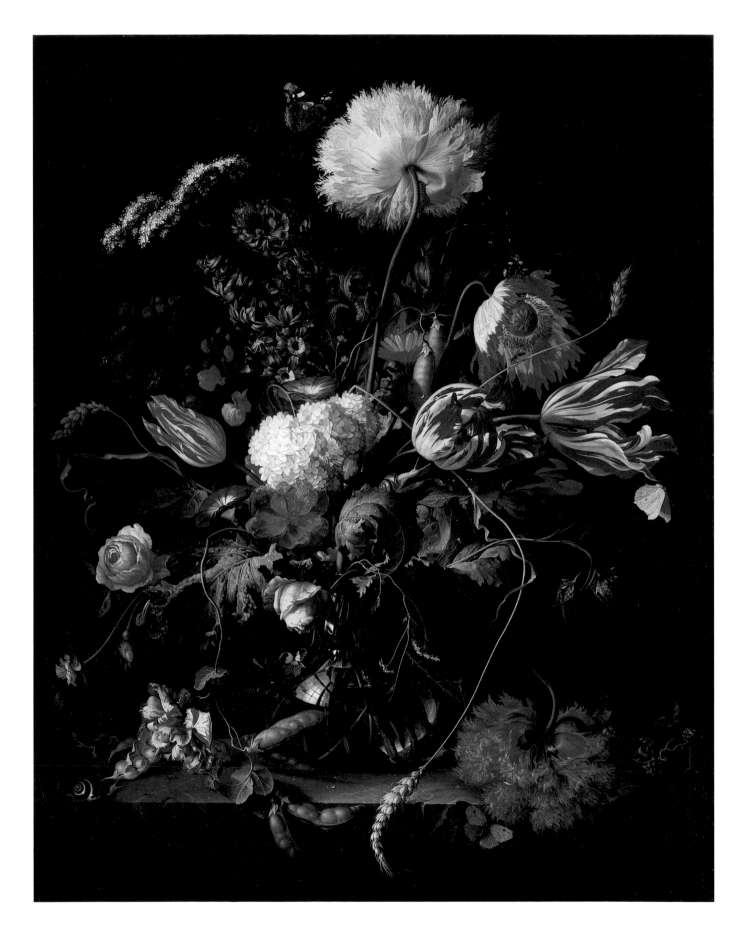

De Heem heeded the lessons learned from the earlier generation of still-life painters—for example, the value of one large, centrally placed blossom, a motif he exploited for dramatic compositional effect in *Vase of Flowers*. Nevertheless, he transformed earlier stylistic traditions to create works that had a new sense of compositional freedom. His loosely conceived, asymmetrical floral arrangements consist of numerous overlapped blossoms, where elongated plant stems establish flowing rhythms for his dynamic yet harmonious compositions. As with Van Aelst's *Vanitas Flower Still Life*, the immediacy of the scene is enhanced by the wheat and flowers protruding over the front edge of the illusionistically painted marble table.

The differences in their training and life experiences are reflected in their artistic ideals. In *Vase of Flowers* De Heem reveled in the multiplicity of creation, not only with the cornucopia of plants and flowers, but also with the minute insects that crawl about their stems and blossoms. As poppies, tulips, roses, wheat stalks, and peas reach out in organic rhythms, butterflies flutter about as though the air around them were rife with the varied aromas of the richly laden bouquet. Van Aelst, on the other hand, focused his vision on a limited number of compositional elements, ones

he carefully selected and boldly depicted. For example, *Vanitas Flower Still Life* is dominated by the asymmetrically twisting form of the hollyhock, which rises from a dense cluster of flowers, including a pink rose, orange marigold, and white chrysanthemums.

Van Aelst intended this elegant and dramatically lit composition to serve as a reminder of the transience of life. An open watch, with its key attached to a shimmering blue ribbon gracefully draped over the front of the marble table, symbolizes the passage of time. This striking *vanitas* element is accompanied by other reminders of death and decay: a spent rose blossom in the middle of the bouquet, deformed leaves, and a curious little mouse who is reminiscent of the mouse in Van de Passe's *Hortus Floridus* (1614) (fig. 21). However, the hovering dragonfly offers the promise of salvation, for, like butterflies, dragonflies only attain their beauty and freedom after their "worldly confinement" in cocoons.[114] The moralizing approach taken by Van Aelst in *Vanitas Flower Still Life* is consistent with seventeenth-century traditions of *vanitas* images, in which flower still lifes were joined with objects such as hourglasses and skulls to convey the notion of life's transience.[115]

De Heem also painted *vanitas* scenes but he emphasized, to a much greater extent than did Van Aelst, that eternal life was possible for those who truly believe in the Christian message. In one instance, De Heem expressly conveyed his theo-

logical message by including a crucifix along with the flower bouquet, skull, and the written warning "but one does not turn to look at the most beautiful flower of all."[116] Moreover, to reinforce his religious message, this Catholic artist utilized explicit plant symbolism to a much greater extent than had flower painters from the first decades of the century.

De Heem was quite consistent in his philosophical approach, and even when paintings contain no explicit symbols of death or resurrection, he apparently intended symbolic associations for flowers and other plants. In *Vase of Flowers*, for example, the message that man can achieve salvation through faith is suggested by allusions to the cross in the subtle reflection of a mullioned window on the glass vase. De Heem further reinforced this message through the types of flowers and plants he included in his bouquet. The prominent white poppy, which was associated with sleep and death, often referred to the Passion of Christ. The morning glory indicated the light of truth since it opens at the break of day and is closed in the dark of night.[117] Grains of wheat symbolize not only the bread of the Last Supper, but also the Resurrection because grain must fall to earth to regenerate. Like wheat, man must die and be buried before achieving eternal life.[118]

FIG. 55. Jan Davidsz. de Heem, *Vase of Flowers* (cat. 16), c. 1660, oil on canvas, National Gallery of Art, Andrew W. Mellon Fund

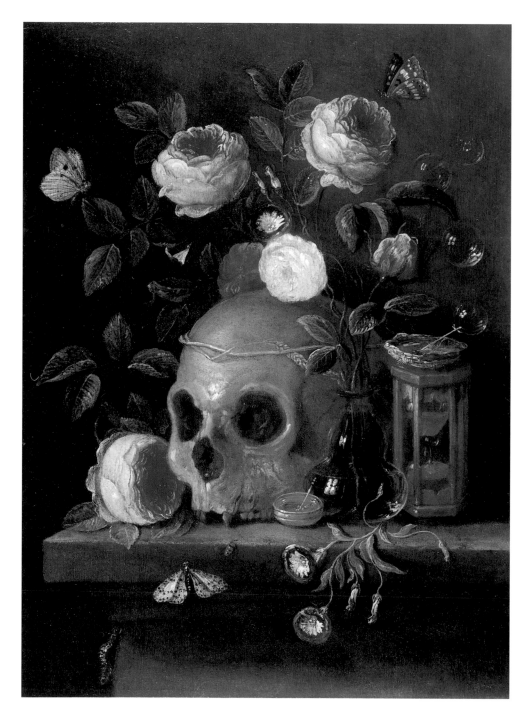

The Impact of De Heem and Van Aelst on
Dutch and Flemish Still-Life Traditions

Another flower painting that also uses
explicit symbolism to offer the hope of
salvation for those who lead a pious life
is Jan van Kessel the Elder's *Vanitas Still Life*
(fig. 56). Van Kessel, a prolific artist
whose father-in-law was Jan Brueghel
the Elder, would have come into contact
with De Heem when the latter lived in
Antwerp. Like De Heem, Van Kessel
understood the powerful emotional
impact of an image of the human skull.
Despite the delicacy of the roses and
morning glories, the fluttering of butter-
fly wings, and the effervescence of soap
bubbles, one's eye stays riveted to this
grim reminder of death. The hourglass
and the bubbles rising from a gold
watchcase merely reinforce the central
message that, with time, life on this
earth vanishes like soap bubbles or with-
ers away like flowers.[119]

Nevertheless, Van Kessel's *vanitas* paint-
ing is not pessimistic, for the skull
wrapped in dried wheat, the butterflies,
and the flowers all offer the promise of
resurrection and salvation. The symbol-
ism of Van Kessel's flowers, which
include the morning glory and roses,
reinforces this message.[120] Although

FIG. 56. Jan van Kessel the Elder, *Vanitas Still Life*
(cat. 20), c. 1665, oil on copper, National
Gallery of Art, Gift of Maida and George Abrams

FIG. 57 (opposite page). Cornelis de Heem,
Still Life of Fruit and Flowers with a Roemer (cat. 15),
mid-1660s, oil on canvas, Private Collection,
Washington

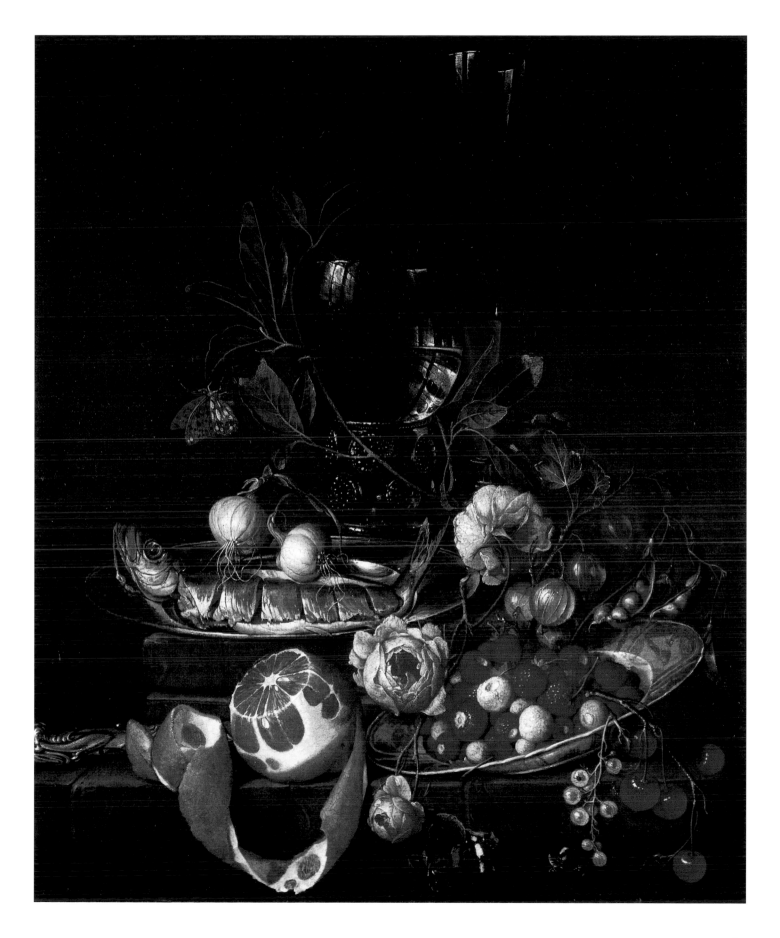

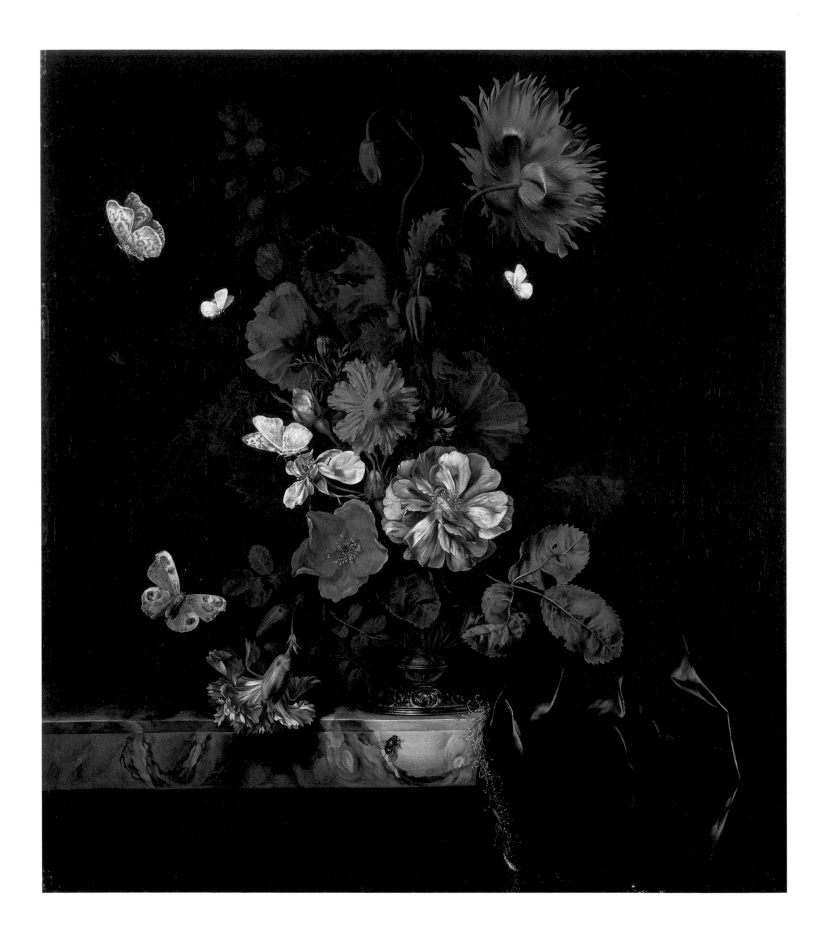

roses were commonly used to symbolize the brevity of life, when placed in conjunction with a skull wrapped in wheat, they allude to the Resurrection.[121]

De Heem applied similar compositional principles to banquet pieces and flower bouquets—principles that his most faithful pupils, including his son Cornelis de Heem (1631–1696), developed in numerous works. Cornelis' sparkling *Still Life of Fruit and Flowers with a Roemer* (fig. 57), probably painted in the mid-1660s after he had returned to Utrecht from Antwerp, has a dynamically spiraling composition of the type he would have learned from his father. Cornelis encourages the eye to flow from the silver-handled knife in the lower left, through the peeled orange and the fruit in the Wan-li dish, past the pink roses and platter with fish and onions before arriving, via the circling vine, at the roemer and tall flute in the background. Cornelis de Heem, who shared his father's predilection for integrating religious concepts into his still-life paintings, must have intended the prominent wine glass encircled by a spray of green leaves to have eucharistic connotations, particularly since it is placed in conjunction with a platter of fish.[122]

Van Aelst's primary influence was on a number of artists who worked in Amsterdam, where he settled after returning

from Italy. He inspired artists like Rachel Ruysch (1664–1750) not only to paint asymmetrical flower bouquets, but also to concentrate on fewer compositional elements in their works. Nicolaes Lachtropius (active in Amsterdam from 1656–1687, and in Alphen aan den Rijn from 1687–c. 1700), who began his career at the very moment Van Aelst returned from Florence, was the master most directly influenced by Van Aelst's dramatic new style. Lachtropius aspired to the same elegant and dynamic concepts, often directly modeling his compositions and even choices of flowers on Van Aelst's work. For example, in *Bouquet of Flowers on a Marble Ledge* (fig. 58), signed and dated 1680, Lachtropius patterned his boldly asymmetrical composition on a Van Aelst model, even placing his bouquet on a marble ledge, one of Van Aelst's most characteristic motifs.[123] Among the individual floral motifs he adapted from this artist are the large red poppy seen from behind and the yellow marigold in the center of the composition (see fig. 54). Lachtropius, however, differed from Van Aelst in his handling of light. He created stark contrasts between brightly colored blossoms and the surrounding darkness, an approach that also allowed him to emphasize the almost surrealistically illuminated butterflies fluttering around the flowers.[124]

Simon Verelst (1644–1721) can hardly be called a follower of Van Aelst, for he had an independent flair that cannot easily be identified with a preexist-

ing tradition. Nevertheless, this artist from The Hague created still lifes with a boldness of vision that shares certain of the older master's stylistic characteristics.[125] He learned from Van Aelst how to focus his forceful compositions around a few elements. However, even Van Aelst never approached the haunting simplicity of Verelst's modestly scaled *Double Daffodils in a Vase*, which he probably painted in the mid-1660s (fig. 59). The composition's clarity of form is unique for this period. Its underlying geometry and narrow tonal range, which consists of pale greens and pinks against an ocher-and-brown backdrop, help establish the image's calm and restful appearance. And its daffodils, like all Verelst's flowers, have precisely that nobility of form so admired by Johann Theodor de Bry in his *Florilegium* of 1612 (see fig. 22).

Jan van Huysum

Jan van Huysum (1682–1749), more than any other artist before or after, could capture the sheer joy of a profuse array of flowers and fruit. In each of these two superb examples (figs. 60, 61), flowers overflowing their terra-cotta vases, and peaches and grapes on the foreground ledges, create a sense of opulent abundance. Woven in and out of the densely packed bouquets of roses, morning glories, hyacinths, auriculae, irises, and narcissi are the rhythmically flowing stems and blossoms of tulips, poppies, and carnations.

FIG. 58. Nicolaes Lachtropius, *Bouquet of Flowers on a Marble Ledge* (cat. 21), 1680, oil on canvas, Teresa Heinz (and the late Senator John Heinz)

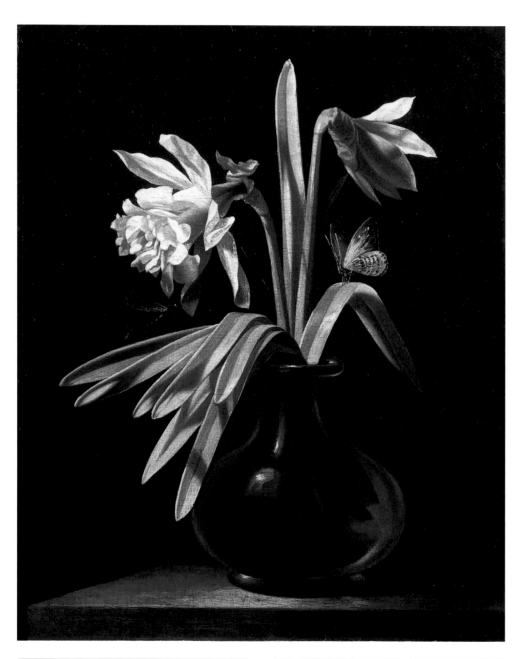

Van Huysum's lasting fame has centered on his exuberant arrangements and technical virtuosity. He could convey both the varied rhythms of a striped tulip's petal and the glistening sheen of its variegated surface. He masterfully integrated insects into his bouquet, as well as suggested the translucence of dewdrops on petals and leaves. He delighted in enhancing the flowers' vivid colors, primarily pinks, yellows, oranges, reds, and purples, with striking light effects that add to the visual richness. He often illuminated blossoms situated at the back of the bouquet, against which he silhouetted darker foreground leaves and tendrils.

Although Van Huysum was trained by his father, Justus van Huysum the Elder (1659–1716), his compositional ideals and technical prowess derive from the examples of Jan Davidsz. de Heem (see fig. 55) and Willem van Aelst (fig. 54).[126] Following De Heem's lead, Jan van Huysum organized his bouquets with sweeping rhythms that draw the eye in circular patterns throughout the composition. Like his predecessor, he also included flowers that do not bloom at the same time, for example, tulips and morning glories. From Van Aelst, on the other hand, Van Huysum learned the advantages of massing brightly lit flowers to focus the dynamically swirling rhythms underlying his compositions.

The dark backgrounds of these paintings are characteristic of works he painted in the second decade of the eighteenth

FIG. 61. Jan van Huysum, *Still Life of Flowers and Fruit in a Niche* (cat. 18), c. 1710/1715, oil on panel, Private Collection

FIG. 62. Jan van Huysum, *Bouquet of Flowers* (cat. 35), 1723, black chalk and gray wash on paper, Private Collection, Washington

FIG. 63. Jan van Huysum, *Bouquet of Flowers* (cat. 34), c. 1720, black chalk and gray wash on paper, Private Collection, Washington

century.[127] One contemporary critic explained that "Van Huysum painted his flowers and fruit for many years on dark backgrounds, against which, in his opinion, they stood out more, and were better articulated."[128] Responding to the evolving tastes of his patrons, he eventually changed his style and situated his floral bouquets against light back-grounds, many of which were outdoor garden settings.

Just how Van Huysum executed his works has never been determined because he was a secretive artist, forbidding anyone, including his own brothers, to enter his studio for fear that they would learn how he purified and applied his colors.[129] However, it seems that he painted at least some of his flowers from life. In a letter reminiscent of the one Jan Brueghel sent to Cardinal Borromeo, Van Huysum explained to a patron that he could not complete a still life that included a yellow rose until it blossomed the following spring.[130] Indeed, this Amsterdam artist's keenness for studying flowers led him to spend a portion of each summer in Haarlem, then, as now, a horticultural center. Nevertheless, the remarkable similarities in the shapes and character of individual blossoms in these two still lifes (figs. 60, 61) indicate that he also adapted drawn or painted models to satisfy pictorial demands.

While no individual studies of flowers can be attributed with certainty to the master, Van Huysum did make exceedingly expressive compositional studies (figs. 62, 63).[131] He approached these works as a painter rather than as a draftsman, using a complex array of techniques, which include oil-soaked charcoal, pen lines, and ink wash, to capture the broad patterns of light and shade flowing across his forms. Although it is generally thought that he did not use these studies as a basis for his paintings, the squaring lines on the drawing dated 1723 suggest otherwise.[132]

the still life also draws the viewer's eye to the figures in this history painting.

Musscher's allegory suggests that Ruysch's still life commands respect because the artist herself was a humanist. While the piece of chalk resting on the easel and the two monkeys playing beneath it refer to Ruysch's ability to copy nature faithfully, the classical sculpture and music on the table beside her indicate her own humanistic interests. These interests, as well as her imagination, allow her to arrange the fruits and flowers lying near her feet into the harmonious, balanced composition of the painted still life.

Musscher's allegory, however, is more than a celebration of one artist's achievements or even of the significance of flower painting within the hierarchy of art. Underlying its symbolic program is the celebration of painting itself, for Ruysch here assumes the guise of Pictura, the personification of painting who practices this noble art with great flourish, dignity, and intelligence.[137]

It seems entirely possible that the gradual theoretical acceptance of flower painting at the end of the century came about because of the increasingly decorative quality of works produced by artists like Rachel Ruysch and Jan van Huysum. Even though their paintings no longer appear to incorporate moral and religious concepts, so fundamental to history painting, their involved compositions leave no doubt about the imaginative capacities of their fertile minds.[138]

NOTES

1. The underdrawing visible on the pink rose is based on one such study.

2. Hendrick Hexham, *Dictionarium, ofte woorden-boeck, begrijpende den schat der Nederlandtsche tale, met de Engelsche uytlegginge*, 2 vols. (Rotterdam, 1648); second edition by Daniel Manly (Rotterdam, 1675–1678). The translations of this phrase in the English-to-Dutch section read: "to paint lively, *Nae't leven schilderen*"; "Painted lively, *Na 't leven geschildert, af-gheset ofte gheconterfeyt.*" In the Dutch-to-English section, the translation reads: "*na het leven Schilderen*, To Paint or Counterfeit to the life."

3. For Borromeo, see Pamela M. Jones, "Federico Borromeo as a Patron of Landscapes and Still Lifes. Christian Optimism in Italy ca. 1600," *The Art Bulletin* 70 (1988), 261–272, especially 269. For Joachim Oudaan, see Lawrence O. Goedde, "A Little World Made Cunningly: Dutch Still Life and Ekphrasis," in *Still Lifes of the Golden Age: Northern European Paintings from the Heinz Family Collection*, ed. Arthur K. Wheelock Jr. [exh. cat., National Gallery of Art] (Washington, 1989), 35–44, particularly 40–42 and note 32, which cites the original text of the poem. For Huygens, see *A Selection of the Poems of Sir Constantijn Huygens (1596–1687)*, trans. Peter Davidson and Adriaan van der Weel (Amsterdam, 1996), 129. Cornelis de Bie, *Het Gulden cabinet van edel de vry schilder-const* (Antwerp, 1661), 215: "Dat door Freer Zeghers const het leven in haer woont." For an excellent assessment of De Bie's treatise, see E.S. de Villiers, "Flemish Art Theory in the Second Half of the Seventeenth Century—An Investigation on an Unexplored Source," *South African Journal of Art History* 2 (1987), 1–11.

4. Elizabeth Blair MacDougall, "Flower Importation and Dutch Flower Paintings, 1600–1750," in Washington 1989, 27–33.

5. See the excellent account of John Prest, *The Garden of Eden: The Botanic Garden and the Re-Creation of Paradise* (New Haven and London, 1981).

6. See Sam Segal, *A Flowery Past: A Survey of Dutch and Flemish Flower Painting from 1600 until the Present* [exh. cat., Gallery P. de Boer and Noordbrabants Museum] (Amsterdam and 's-Hertogenbosch, 1982), 5, 13.

7. For a discussion of the allegorical associations of the garden and its plants within the Christian tradition see Prest 1981, 21–26. For example, as is noted by Sam Segal, *A Fruitful Past: A Survey of the Fruit Still Lifes of the Northern and Southern Netherlands from Brueghel till Van Gogh* [exh. cat., Gallery P. de Boer and Herzog Anton Ulrich-Museum] (Amsterdam and Braunschweig, 1983), 39, the triple lobes of the leaves of the strawberry plant were associated with the Trinity; its white flower, to purity and chastity; and the creeping manner of its growth, to humility. The time of its flowering in early spring related it to the Annunciation and the Incarnation of Christ.

8. The *Warburg Hours* may be found at the Library of Congress, Washington, Rare Book Collection, MS 139. Marilyn Stokstad and Jerry Stannard, *Gardens of the Middle Ages* [exh. cat., Spencer Museum of Art, University of Kansas] (Lawrence, Kans., 1983), 98–99, no. 1.

9. See note 7 for the symbolism of the strawberry plant.

10. See Thomas DaCosta Kaufmann and Virginia Roehrig Kaufmann, "The Sanctification of Nature. Observations on the Origins of Trompe L'Oeil in Netherlandish Book Painting of the Fifteenth and Sixteenth Centuries," in *The Mastery of Nature: Aspects of Art, Science, and Humanism in the Renaissance*, by Thomas DaCosta Kaufmann (Princeton, 1993), 33–45.

11. Dagmar Thoss, *Flämische Buchmalerei: Handschriftenschätze Burgunderreich* [exh. cat., Österreichische Nationalbibliothek] (Vienna, 1987), 130–131, no. 84, ill. 102.

12. Pedacius Dioscorides was a Greek physician from Asia Minor who served in the army of the emperor Nero. His treatise *De materia medica*, which was frequently republished in the sixteenth century, described around six hundred plants from the Near East. For an excellent study of the importance of classical authorities in the fifteenth and sixteenth centuries, see Karen Meier Reeds, "Renaissance Humanism and Botany," *Annals of Science* 33 (1976), 519–542.

13. See F. de Nave, "From Auxiliary Science to Independent Discipline: Botany in the Southern Netherlands during the Sixteenth Century," in *Botany in the Low Countries (End of the 15th Century—ca. 1650)* [exh. cat., Museum Plantin-Moretus and Stedelijk Prentenkabinet] (Antwerp, 1993), 11.

14. The emphasis during antiquity seems to have been placed much more on descriptions of plants than on images of them. Reeds 1976, 530, notes that Pliny, who praised trompe l'oeil effects achieved by Parrhasius and Zeuxis, condemned painters for trying to imitate plants. He felt that the results would be deceptive, for painters could not match nature's original nor could they depict the appearance of plants in their various seasons (Pliny *Historia naturalis* 25.4).

15. Translated in Erwin Panofsky, *The Life and Art of Albrecht Dürer* (Princeton, 1971), 279.

16. For an excellent analysis of these works, see Fritz Koreny, *Albrecht Dürer and the Animal and Plant Studies of the Renaissance* (Boston, 1985).

17. For a careful assessment of the attribution issues associated with this work, which is catalogued under Dürer's name at the National Gallery of Art, see Koreny 1985, 206.

18. For a discussion of the stylistic changes in the illustrations of some early herbals, see Gavin D.R. Bridson, Donald E. Wendel, et al., *Printmaking in the Service of Botany* [exh. cat., Hunt Institute for Botanical Documentation, Carnegie-Mellon University] (Pittsburgh, 1986), nos. 1–3.

19. For a discussion of Weiditz' watercolor drawings for this publication, see Koreny 1985, 228–231.

20. F. de Nave in Antwerp 1993, 13.

21. Helena Wille, "The Botanical Works of R. Dodoens, C. Clusius and M. Lobelius," in Antwerp 1993, 33.

22. This point is made by Reeds 1976, 531.

23. Rather than listing and describing plants according to their medicinal or alimentary function, as had been done since antiquity, Fuchs classified plants in alphabetical order.

24. Meyer's drawings are preserved at the Österreichische National-bibliothek in Vienna.

25. Translated in Wilfrid Blunt, *The Art of Botanical Illustration: An Illustrated History* (Mineola, N.Y., 1994), 51; first published in London in 1950.

26. Leonhart Fuchs, *Den Nieuwen Herbarius* (Basel, 1543), published by Michael Isingrin.

27. Quoted in C. Depauw, "Peeter vander Borcht (1535/40–1608): The Artist as *Inventor* or *Creator* of Botanical Illustrations?" in Antwerp 1993, 50: "naer dat leven gheconterfeyt ende met hueren colueren ende verwe[n] wel ende perfectelick afgheset" (drawn from life, or drawn lively, and with applied colors well and perfectly painted).

28. Beyond extending the range of plants described and illustrated by Fuchs, Dodoens transformed the organization of his herbal. He supplanted the traditional alpha-betical ordering, which had been made extremely cumbersome through the variety of names given to newly discovered plants, with a classification system based on plants' utilitarian characteristics. He grouped together flowers and fragrant herbs, roots and medicinal herbs, vegetables and thistles, roots and fruit, and trees and woody plants. See Antwerp 1993, 100–101, no. 27.

29. For a discussion of Ludger tom Ring's oil studies on paper in the Österreichische Nationalbibliothek, Vienna, and his artistic significance, see Koreny 1985, 240–247 and Sam Segal, "Blumen, Tiere und Stilleben von Ludger tom Ring d. J.," in *Die Maler tom Ring*, ed. Angelika Lorenz [exh. cat., Westfälisches Landesmuseums für Kunst und Kulturgeschichte] (Münster, 1996), 1, 119–132.

30. For a discussion of the inscriptions on some of these vases, see Segal in Münster 1996, 1, 120–122.

31. One such study, illustrated in Koreny 1985, 246, no. 90, includes the four large red field poppies in this painting as well as the soapwort, meadow buttercup, corn camomile, corn cockle, and snapdragon. For the identification of the flowers in this painting, see Münster 1996, 2, 640, no. 195.

32. Rembert Dodoens, *Histoire des plantes*, trans. C. Clusius (Antwerp, 1557); published by Jan van der Loe.

33. After the 1563 death of Jan van der Loe, the publisher of *Cruijdeboeck*, Dodoens began working with Christopher Plantin, with whom he planned a whole new botanical study, *Stirpium Historiae Pemptades Sex*, which was eventually published in Antwerp in 1583. *Florum et Coronariarum Odoratarumque* is one of the smaller books that Dodoens published with Plantin in the interim, all of which were eventually incorporated into the larger publication. *Stirpium Historiae Pemptades Sex* included 1,358 illustrations, many of which depicted exotic flowers that were being introduced in increasing numbers to The Netherlands from distant lands.

34. Following in the tradition of Brunfels, Dodoens hired a specialist in botanical illustrations for this work, Peeter vander Borcht (1535/1540–1608), an artist from Dodoens' hometown of Mechelen who eventually designed and cut as many as three thousand woodcuts as botanical illustrations for Plantin. See C. Depauw in Antwerp 1993, 47.

35. Translated in Antwerp 1993, 144.

36. Four additional plates by an unknown follower of Hans Vredeman de Vries are appended to the copy of Hans Vredeman de Vries, *Hortorum Viridariorumque* (Antwerp, 1583) located at Dumbarton Oaks, Washington. In this print of an elaborate garden design, figures splash each other from a fountain decorated with a statue of Venus. Another of these appended images depicts the garden as a setting for lovers at a feast, while two other garden designs are enlivened with biblical stories associated with illicit love: Susanna and the elders, and David and Bathsheba. The influential garden designs of Vredeman de Vries (1527–c. 1606) are all situated within a castle context, where walls and arbors divide geometrically conceived gardens into various subsections, each with its own distinctive character.

37. The expedition, led by Lieutenant René Goulaine de Laudonnière, was undertaken between 1564 and 1566. An account of the trip, illustrated with engravings after drawings by Le Moyne de Morgues, was published as part 2 of Theodor de Bry, *Brevis Narratio Eorum Quae in Florida Americae Provincia Gallis Acciderunt* (Frankfurt, 1591).

38. Paul Hulton, in *The Work of Jacques Le Moyne de Morgues: A Huguenot Artist in France, Florida, and England* (London, 1977), 1, 78–80, speculates that Le Moyne de Morgues may have been trained in a miniaturist workshop following in the tradition of Jean Bourdichon (1457–1521). Hulton, however, also notes that Le Moyne de Morgues' emphasis on the color and texture of flowers relates to the illuminated manuscript traditions that developed in Ghent and Bruges.

39. Lucia Tongiorgi Tomasi, *An Oak Spring Flora: Flower Illustration from the Fifteenth Century to the Present Time* (Upperville, Va., 1997), 34.

40. These watercolors are now in the British Museum, London. See Hulton 1977 for catalogue listings and discussion of their significance.

41. Van de Passe, who was born in Zeeland and raised as a Mennonite, trained in Antwerp before fleeing to Aachen in 1589 for religious reasons. He then lived in Cologne before moving to Utrecht in 1612. For information about his early training, see Ilja M. Veldman, "Keulen als toevluchtsoord voor Nederlandse kunstenaars (1567–1612)," *Oud Holland* 107 (1993), 34–57.

42. The makeup of this florilegium, which was published in Dutch, Latin, French, and English, is extremely complicated. The book is divided into two parts, with the first part subdivided into four sections. The copies after *La Clef des champs* occur in the second part of *Hortus Floridus*, the so-called *Altera pars*. This part was made first, and was probably published separately prior to 1614. The cruder style of these engravings indicates that the engraver was either Van de Passe's father and teacher, or his brother Willem (c. 1598–c. 1637). These engravings are based on watercolor drawings that Le Moyne de Morgues had used as models for *La Clef des champs*. For further discussion, see Hulton 1977, 1, 81–82.

43. From De Bry's dedication of an edition published in 1613 (now at the Oak Spring Garden Library, Upperville, Va.); translated in Tongiorgi Tomasi 1997, 48.

44. Hoefnagel, who arrived at the court in 1577, continued to work in Munich as court artist for Duke Wilhelm V after Duke Albrecht V died in 1579. After he was dismissed from the court in 1591 for his religious beliefs, he moved to Frankfurt, where he worked under the protection of Emperor Rudolf II.

45. Koninklijke Bibliotheek Albert I, Brussels, Department of Manuscripts, Cod. IV, 40. The manuscript had originally been compiled in the late fifteenth century. See Kaufmann 1993, 27–28, figs. 13 and 14, and Thea Vignau-Wilberg, *Archetypa Studiaque Patris Georgii Hoefnagelii: Nature, Poetry and Science in Art around 1600* (Munich, 1994), 32–34.

46. For a summarized history of this manuscript, see John Oliver Hand, et al., *The Age of Bruegel: Netherlandish Drawings in the Sixteenth Century* [exh. cat., National Gallery of Art] (Washington, 1986), 198–200, no. 73.

47. Although Hoefnagel became associated with the court of Rudolf II in 1590, he chose to live in Frankfurt, where he stayed from 1591 until 1594. He lived in Vienna from 1594 until his death in 1600.

48. Clusius was at that time preparing the Latin translation of Le Moyne de Morgues' French text for Theodor de Bry's publication *Brevis Narratio Eorum Quae in Florida Americae Provincia Gallis Acciderunt* (Frankfurt, 1591). For a transcription and English translation of this text, see Hulton 1977, 1, 87–152. It is also probable that Clusius owned watercolors Le Moyne de Morgues used as models for his florilegium, *La Clef des champs* (London, 1586). Since Clusius moved to Leiden in 1593, this hypothesis may account for their influence on the work of Jacques de Gheyn II and their use as models in *Hortus Floridus*. See note 42.

49. See Vignau-Wilberg 1994. *Archetypa* consists of four sections, each of which has a title page and twelve leaves. It is probable that the entire *Archetypa* was published as a book in 1592, but the character of its original appearance is not certain.

50. Since some of the images in *Archetypa* are identical to Hoefnagel's miniatures in the marginalia of the *Book of Hours of Philip of Cleves* and others are found in the *Four Elements*, it is likely that all are based on a lost model book maintained by the artist. See Marjorie Lee Hendrix, "Joris Hoefnagel and the Four Elements: A Study in Sixteenth-Century Nature Painting" (Ph.D. Diss., Princeton University, 1984), 173–176; Vignau-Wilberg 1994, 11, 45–54.

51. Upper text: "Una hirundo non facit ver"; lower text: "Omnia vere vigent, et veris tempore florent / et totus feruer Veneris dulcedine mundus." Vignau-Wilberg 1994, 68, translates the bottom text as "All things flourish in spring, and in springtime all things are in flower and the whole world glows with the sweetness of Venus." The motto above the image can be translated as "One swallow does not make spring." She identifies this text as coming from Erasmus, *Adagiorum* (Antwerp, 1564), 262 (1.7.94), who understood this saying to mean that "one day is not time enough to acquire virtue or education." The interpretation of this image discussed in the text is based on Thea Vignau-Wilberg, *Durch die Blume: Natursymbolik um 1600* [exh. cat., Staatliche Graphische Sammlung München] (Munich, 1997), 22, no. 49.

52. Aside from Jacob Hoefnagel's flower bouquet in *Archetypa* (see fig. 24), see Hendrick Hondius' 1599 engraving of a vase of flowers in a niche before a fanciful landscape. Hondius' print, which is illustrated in Sam Segal, *Netherlandish Flower Painting of Four Centuries* (Amstelveen, 1990), 49, fig. 27, is based on a design by the Delft artist Elias Verhulst.

53. "Door verscheydenheyt is Natuere schoone, / Dat sietmen, als schier met duysent colueren / Het Aerdtrijck ghebloeyt om prijs staet ten toone, / Teghen den sterrighen Hemelschen throone." Karel van Mander, *Den Grondt der edel vrij schilderconst*, 16v. v. 20 in *Het Schilder-boeck* (Haarlem, 1604). The text was translated by Paul Taylor, *Dutch Flower Painting 1600–1720* (New Haven and London, 1995), 86.

54. See note 3.

55. This work was convincingly attributed to Hoefnagel by Ingvar Bergström. Documents do not mention oil paintings by Hoefnagel, only watercolors on parchment. Only one example survives, a symbolically conceived and symmetrically composed vase of flowers that is conceptually related to plates from *Archetypa*. For an illustration, see Koreny 1985, 148, no. 91. *Flower Still Life with Alabaster Vase* is monogrammed JH in the background at the right.

56. I would like to thank Sally Wages for stressing this point in discussions with me.

57. See Antwerp 1993, nos. 93 and 97.

58. See note 48.

59. See Van Mander 1604, fol. 294v: "een clee Bloempotken nae t'leven...dit is heel suyver ghehandelt, en nae een eerste begin verwonderlijck." See Florence Hopper Boom, "An Early Flower Piece by Jacques de Gheyn II," *Simiolus* 8 (1975/1976), 195–198, for a discussion of a painting that may be identical to this early work. The symmetrical composition of this painting, which is totally dependent on a 1594 design by Hoefnagel (see Koreny 1985, no. 91), indicates a date from the late 1590s and not 1600–1603 as suggested by Florence Hopper Boom.

60. For a discussion of Van Os as a collector, see Marten Jan Bok, "Art-Lovers and Their Paintings: Van Mander's Schilder-boeck as a Source for the History of the Art Market in the Northern Netherlands," in *Dawn of the Golden Age: Northern Netherlandish Art 1580–1620*, ed. Ger Luijten et al. [exh. cat., Rijksmuseum] (Amsterdam, 1993–1994), 141–142.

61. The album is now in the possession of the Fondation Custodia (F. Lugt collection), Institut Néerlandais, Paris. For a discussion of this album, see *Le Héraut du dix-septième siècle: Dessins et gravures de Jacques de Gheyn II et III* [exh. cat., Institut Néerlandais] (Paris, 1985), 18–33,

no. 9. For the relationship of this album to Clusius, see Florence Hopper, "Clusius' World: The Meeting of Science and Art," in *The Authentic Garden: A Symposium on Gardens*, ed. L. Tjon Sie Fat and E. de Jong (Leiden, 1991), 13–37.

62. Hopper in Fat and De Jong 1991, 32–37, attempts to identify the flowers depicted by De Gheyn with those listed in the 1594 and 1596 inventories of the *Hortus Botanicus* in Leiden. The connections to Clusius' garden may be one reason that Emperor Rudolf II in Prague acquired this album for his extensive collection of nature studies.

63. The intriguing suggestion that De Gheyn was influenced by Jacques Le Moyne de Morgues was made by Beatrijs Brenninkmeijer-de Rooij, *Roots of Seventeenth-Century Flower Painting: Miniatures, Plant Books, Paintings* (Leiden, 1996), 42–43. The insects in De Gheyn's Paris album are particularly close to those made by Hoefnagel in *Ignis* (see fig. 23).

64. Paris 1985, no. 9, fol. 18.

65. See, for example, Sam Segal, "The Flower Pieces of Roelandt Savery," in *Leids Kunsthistorisch Jaarboek* (Leiden, 1982), 309–337.

66. Another version of this work, also signed and dated 1603, is in the Centraal Museum, Utrecht, inv. no. 6316. It is discussed in *Roelant Savery in Seiner Zeit (1576–1639)* [exh. cat., Wallraf-Richartz-Museum and Centraal Museum] (Cologne and Utrecht, 1985–1986), 78–79, no. 2, ill.

67. A number of important collectors and art dealers lived in Middelburg, including Melchior Wyntgis, to whom Van Mander dedicated two of his treatises, *Den Grondt der edel vry schilder-const* and *Het Leven der oude antijcke doorluchtighe schilders*. Wyntgis owned paintings by Bosschaert. See Bok in Amsterdam 1993–1994, 147–148.

68. Quoted from Laurens J. Bol, *The Bosschaert Dynasty. Painters of Flowers and Fruit* (Leigh-on-Sea, 1960), 16. The Dutch text from J. Cats, *Houwe-lyck* (Middelburg, 1625), (part 4, "Vrouwe"), reads "Daer heeftse menich fruyt uyt alle vreemde landen, / Daer menich aerd-gewas van alle verre stranden, / Daer bloemen sonder naem...."

69. For Lobelius, see Antwerp 1993, 121–123.

70. I am most grateful to C.S. Oldenburger-Ebbers for sharing with me information provided to her by P.W. Sijnke, Gemeente-archivaris van Middelburg, in a letter dated 26 September 1990.

71. The engraving (fig. 28), whose title here is taken from the motto accompanying the print, appears in Adriaen Pietersz. van de Venne, *Zeevsche nachtegael* (Middelburg, 1623).

72. Nothing is known of Ambrosius' training, or whether he had contact with the famed botanist Lobelius. It seems probable that he learned his craft from his father, who was presumably the Antwerp painter Ambrosius Bosschaert. In the 1590s, after the family had moved to Middelburg for religious reasons, an

Ambrosius Bosschaert was active there in the Saint Luke's Guild, but it is not clear whether this painter was the father or the son.

73. Bol 1960, 18.

74. For an assessment of these repetitions, see Sam Segal in *Masters of Middelburg* [exh. cat., Kunsthandel K. and V. Waterman] (Amsterdam, 1984), 31–41.

75. Many of these same flowers appear in a similar composition (see Ingvar Bergström, *Dutch Still-Life Painting in the Seventeenth Century*, trans. Christina Hedström and Gerald Taylor [London, 1956], 67, fig. 52), which suggests that Bosschaert may also have based some of his paintings on preexisting compositions.

76. As Fred Meijer notes in Amsterdam 1993–1994, Bosschaert depicted identical roses in paintings from many periods of his career.

77. Writers associated butterflies, which only attain their beauty and freedom after their worldly confinement in cocoons, to the immortal souls of those who had lived a pious life. See Jacob Cats, *Proteus ofte minne-beelden verandert in sinne-beelden* (Rotterdam, 1627), emblem 52.

78. The inscription is written in French, a language often used at the court of the prince of Orange in The Hague. Although the author is not known, it must have been added shortly after Bosschaert's death. Since the plaque was part of the original conception of the painting, it may be that this work

was expressly commissioned by one of Bosschaert's patrons to commemorate his fame. Bosschaert died in The Hague while delivering a painting to a member of the court; thus it is quite likely that Bosschaert painted this work as well for a member of the court. For the circumstances of his death, see Amsterdam 1993–1994, 302–303.

79. For documentary evidence about Van den Berghe's life and art, see L.J. Bol, "Een Middelburgse Breughel-groep," *Oud Holland* 71 (1956), 183–195.

80. Sam Segal has counted thirteen butterflies in a painting by Van den Berghe dating 1617. See Amsterdam 1984, 76.

81. The Wan-li period extended from 1573–1619.

82. For the proposal that these two paintings are those in the National Gallery of Art (access. nos. 1992.51.1 and 1992.51.2), see Arthur K. Wheelock Jr., *Dutch Paintings of the Seventeenth Century* (New York and Oxford, 1995), 5–8.

83. Although Bosschaert provided Van der Ast the model for depicting such symmetrically placed wicker baskets filled with flowers and fruit, the painting's soft forms, diffuse contours, muted colors, and focused light reflect the influence of Savery on the young artist. For Bosschaert's basket of flowers, see Ingvar Bergström, "Baskets with Flowers by Ambrosius Bosschaert the Elder and Their Repercussions on the Art of Balthasar

van der Ast," *Tableau* 6, no. 3 (1983 –1984), 66, fig. 1. Van der Ast also learned from Bosschaert the art of making drawings or watercolor studies of flowers, fruits, and shells to use as models that could be variously combined. The elegant red-and-white variegated tulip that hangs over the edge of the basket in *Basket of Flowers*, for example, can be found in a number of his compositions. Bol 1960 has identified this tulip, known as a Summer Beauty, in at least nine other compositions.

84. Cited in Gertraude Winckelmann-Rhein, *The Paintings and Drawings of Jan "Flower" Brueghel* (New York, 1969), 22.

85. As translated in Brenninkmeijer-de Rooij 1996, 49. Brenninkmeijer-de Rooij relates Brueghel's depiction of the mouse to a comparable image, in reverse, that appears in Jacob Hoefnagel's *Archetypa* (part 3, no. 2). Vignau-Wilberg 1994, 51, notes that the rosebuds appear, in reverse, in part 1, no. 5. She suggests that Brueghel must have seen Joris' painted pattern book.

86. Translated in Brenninkmeijer-de Rooij 1996, 49.

87. Brenninkmeijer-de Rooij 1996, 57, fig. 1. The painting is in the Pinacoteca Ambrosiana, Milan.

88. For an excellent assessment of the implications of Brueghel's letter to Borromeo and his agent Bianchi, see Brenninkmeijer-de Rooij 1996, 47–90.

89. Jones 1988.

90. The book begins and ends with its famous refrain: "Vanity of vanities, saith the Preacher...all is vanity" (chapter 1, verse 2 and chapter 12, verse 8).

91. Illustrated in Arthur K. Wheelock Jr., "Still Life: Its Visual Appeal and Theoretical Status in the Seventeenth Century," in Washington 1989, 19, fig. 9. While I believe that the degree to which flower still-life paintings reflect *vanitas* ideas has been greatly exaggerated in the literature, Brenninkmeijer-de Rooij 1996, 70 and 90, note 77, overstates the case when she argues that no evidence suggests that flower pieces were intended as symbols of ephemera. To support her opinion, she maintains that the poem inscribed on Brueghel's still life was painted later. Brueghel, however, composed this still life with enough space below the ledge for a poem to be added.

92. Such images, which were often found in prints, might include a bouquet together with a skull and be accompanied by an inscription warning about the inevitability of death, such as MEMENTO MORI (Be mindful of death) or QVIS EVADIT / NEMO (Who escapes? No man). For MEMENTO MORI, see Simon de Passe after Crispijn de Passe the Younger, *Vanitas*, 1612, engraving, reproduced in Segal 1990, 154, no. 6. Segal translates the text accompanying De Passe's engraving as "Behold, the vicissitudes of life and death are like the glory of a charming flower that remains

unharmed for but a short time. It is thus that a child's life moves on with faltering steps. No sooner is it born, than its fragile life has gone." For QVIS EVADIT / NEMO, see Hendrick Goltzius, *Young Man Holding a Skull and a Tulip*, 1614, pen drawing, Pierpont Morgan Library, New York, inv. no. III, 145, reproduced in E.K.J. Reznicek, *Die Zeichnungen von Hendrick Goltzius*, 2 vols. (Utrecht, 1961), no. 332.

93. David Freedberg, "The Origins and Rise of the Flemish Madonnas in Flower Garlands," in *Münchner Jahrbuch der Bildenden Kunst*, 3d series, 32 (Munich, 1981), 123–131.

94. Freedberg 1981, 116. Brueghel's painting, fig. 3 in Freedberg's article, is in the Pinacoteca Ambrosiana, Milan.

95. See note 3.

96. Among the other masters with whom Seghers worked were Thomas Willeboirts Bosschaert (1613/1614–1654), Hendrick van Balen, Erasmus Quellinus II (1607 –1678), who painted illusionistically rendered sculptural groups, and Peter Paul Rubens (1577–1640).

97. Translated in Brenninkmeijer-de Rooij 1996, 50.

98. For an excellent overview of the relative values attached to flowers and flower still lifes, as well as an assessment of the tulipmania, see Taylor 1995, 1–27.

99. Sam Segal, *Tulips by Anthony Claesz* (Maastricht, 1987), indicates that about seven hundred tulips had been cultivated in The Netherlands at that time.

100. Jacob Marrel used this variant spelling of "naer het leven" in his *Tulpenboek*. The son of a Huguenot couple who settled in the Protestant sanctuary at Frankenthal, Marrel studied in Frankfurt with Georg Flegel (1566–1638) before moving to Utrecht in 1634. He lived in Utrecht until 1649, when he returned to Frankfurt. Aside from being a painter and draftsman, Marrel sold paintings and tulip bulbs.

101. For a fuller discussion of this book, see Tongiorgi Tomasi 1997, 284–288.

102. For Holsteyn's tulip drawings, see Tongiorgi Tomasi 1997, 82. In addition, two tulip drawings by Judith Leyster (1609–1660) are part of a tulip book in the Frans Halsmuseum, Haarlem.

103. John Dixon Hunt and Erik de Jong, eds., *The Anglo-Dutch Garden in the Age of William and Mary Journal of Garden History* 8 (1988), no. 10, 121–122. The album, *Plusieurs especes de fleurs dessinées d'après le naturel*, is in the Rijksprentenkabinet, Amsterdam. For an illustration of Holsteyn's drawing from this album, see Peter Schatborn, *Flowers and Plants* (Amsterdam, 1994), 20.

104. William W. Robinson, *Seventeenth-Century Dutch Drawings: A Selection from the Maida and George Abrams Collection* [exh. cat., Rijksmuseum] (Amsterdam, 1991), 218, no. 100.

105. For a discussion of Saftleven's twenty-seven botanical drawings for Agnes Block, see Wolfgang Schulz, *Herman Saftleven 1609–1685: Leben und Werke* (Berlin and New York, 1982), 95–101, 481–488.

106. Tongiorgi Tomasi 1997, 86, notes that a similar florilegium, dated 1668, is in the Biblioteca Nazionale Centrale in Rome.

107. See Gill Saunders and Jenny de Gex, *So Many Sweet Flowers: A Seventeenth-Century Florilegium. Paintings by Johann Walther 1654* (London, 1997).

108. See Tongiorgi Tomasi 1997, 89. See also H. de la Fontaine Verwey, "The Binder Albert Magnus and the Collectors of His Age," *Quaerendo*, 1/3 (1971), 158–178.

109. Arnold Houbraken, *De Groote schouburgh der Nederlandsche konstschilders en schilderessen* (The Hague, 1753), 2, 186–188.

110. This drawing is one of twelve gouache drawings of tulips and fritillarias sold at Sotheby's, London, 15 March 1996, lots 101–106. The drawings were accompanied by a note indicating that the flowers were from the garden of Louis de Marle.

111. Johan van Gool, *De Nieuwe schouburg der Nederlandtsche kunstschilders en schilderessen* (The Hague, 1750), 1, 248–256.

112. His teacher was his uncle, the Delft still-life painter Evert van Aelst (1602–1658), whose style appears to have had little impact on the artist.

113. Houbraken 1753, 1, 230.

114. The prime version of this composition, signed and dated 1656, is in the Gemäldegalerie Alte Meister, Kassel, inv. no. GK 905. The compositions are essentially identical, although the Kassel version has neither the mouse nor the dragonfly. The absence of the dragonfly indicates that Van Aelst did not originally intend for his painting to include the promise of salvation. In this respect, his composition is not as thematically integrated as De Heem's *Vase of Flowers*. For a discussion of the allegorical meaning of butterflies see note 77.

115. See note 92.

116. The text "Maer naer d'Alders[c]hoonste Blom / daer en siet'-men niet naer' om" occurs in De Heem's *Flowers with Crucifix and Skull*, c. 1665, Munich, Alte Pinakothek, inv. no. 568. See Beverly Louise Brown and Arthur K. Wheelock Jr., *Masterworks from Munich: Sixteenth-to-Eighteenth-Century Paintings from the Alte Pinakothek* [exh. cat., National Gallery of Art] (Washington, 1988), 136–137, no. 33, repro.

117. See Washington 1988, 141.

118. The bramble, which was believed to be the burning bush in which the angel of the Lord appeared to Moses, was associated with divine love that cannot be consumed.

119. The soap bubbles are a visual reference to *homo bulla*, the idea that man's life is like a bubble. For a discussion of this theme in Dutch art and literature, see Eddy de Jongh et al., *Tot Lering en vermaak: Betekenissen van Hollandse genrevoorstellingen uit de zeventiende eeuw* [exh. cat., Rijksmuseum] (Amsterdam, 1976), 45–47.

120. As has been discussed, roses had a number of religious associations, many of which were related to the Virgin. A white rose also symbolized Christ's love, and a red rose alluded to his Passion, a concept reinforced by the thorns lining its stem. See Amsterdam and 's-Hertogenbosch 1982, 5, 13.

121. For literary associations between the brevity of life and the fragility of the rose, see Amsterdam and 's-Hertogenbosch 1982, 17–18. Hendrick Andriessen (1607–1655) depicts a rose just above a skull in his *Vanitas*, Musée des Beaux-Arts, Ghent, inv. no. 1914-DE. Alain Tapié, *Les Vanités dans la peinture au XVIIe siècle* [exh. cat., Musée des Beaux-Arts and Musée du Petit Palais] (Caen and Paris, 1990–1991), 242, no. O.14, describes this rose as a symbol of the Resurrection. The mythology surrounding the *Resurrection Flower*, which is not a rose, is described by Lesley Gordon, *The Mystery and Magic of Trees and Flowers* (Exeter, 1985), 29–30.

122. As in Jan Davidsz. de Heem's *Vase of Flowers*, the dynamic composition is made even more immediate in the way that the orange peel, rose, butterfly, and fruit hang over the foreground plane. For the numerous Christological associations of fish, see James Hall, *Dictionary of Subjects and Symbols in Art* (New York, 1974), 122.

123. A close comparison, for example, is Willem van Aelst's *Flower Still Life with a Watch*, Mauritshuis, The Hague, inv. no. 2. Illustrated in *The Mauritshuis in Bloom: Bouquets from the Golden Age* [exh. cat., Mauritshuis] (The Hague, 1992), 54–55, no. 2.

124. Lachtropius probably developed this interest in butterflies from the example of Otto Marseus van Shrieck, who had returned from Florence with Van Aelst in 1656.

125. Simon Verelst, who was born and raised in The Hague, presumably studied with his father, Pieter Verelst, who painted genre scenes. Simon became a member of Confrérie Pictura, the painters' fraternity in The Hague, in 1663, but left for England in 1669, where he spent the rest of his life. He was extremely successful in England, where he worked for the second duke of Buckingham. Charles II owned six of his paintings. However, success seems to have gone to his head: he described himself as King of Painters and God of Flowers. He eventually went insane.

126. Justus van Huysum, who also trained Jan's brothers, Justus the Younger, Jacob, and Michiel, ran a flourishing art business. Justus not only painted large flower pieces, often as part of complete decorative schemes that he designed for patrons' homes, he also was active as an art dealer.

127. Van Huysum must have painted *Still Life of Flowers and Fruit in a Niche* at about the time he painted a flower piece in the Staatliche Kunsthalle, Karlsruhe, dated 1714, which also depicts a bouquet in a dark niche. See Maurice Harold Grant, *Jan van Huysum, 1682–1749* (Leigh-on-Sea, 1954), no. 12.

128. Translated in Taylor 1995, 191.

129. Van Huysum had only had one pupil, Margaretha Haverman (1720–1795), whom he apparently took on only in response to great pressure from her father. It is widely reported that Haverman's work soon inspired such jealousy in her teacher that she had to leave his studio. For a discussion of biographers' accounts of Van Huysum, see Paul Taylor, *Dutch Flower Painting, 1600–1750* [exh. cat., Dulwich Picture Gallery] (London, 1996), 84–92.

130. For Brueghel's letter, see page 48, note 86. Van Huysum's letter, dated 17 July 1742, was written to A.N. van Haften, agent for the duke of Mecklenburg. See Friedrich Schlie, "Sieben briefe und eine quittung von Jan van Huijsum," *Oud-Holland* 18 (1900), 141. Some of Van Huysum's paintings have dates from consecutive years. See Grant 1954, nos. 19 and 162.

131. Christopher White, *The Flower Drawings of Jan van Huysum* (Leigh-on-Sea, 1964), rightly concludes that a large group of flower studies in the British Museum cannot be conclusively attributed to the artist.

132. Van Huysum may have used such studies to provide general compositional designs for paintings that he then adapted to accommodate specific flowers he had in his possession. The composition of the 1723 drawing is similar, although not identical to Van Huysum's *Flowers in an Urn*, c. 1620, National Gallery of Art, Washington. See Wheelock 1995, 142–145, ill.

133. Samuel van Hoogstraten, *Inleyding tot de hooge schoole der schilderkonst* (Rotterdam, 1678), 76, described still-life painters as "gemeene Soldaeten in het veltleger van de konst zijn" (the ordinary soldiers in the army of art).

134. The correct attribution of this painting to Musscher was first made in 1989 by Fred G. Meijer from the Rijksbureau voor Kunsthistorische Documentatie. Musscher was primarily a genre painter and portraitist, but he also specialized in depictions of artists in their studios.

135. The medallion has not been identified and may well be fanciful.

136. Ruysch was the daughter of one of the most eminent surgeons in Amsterdam, Frederik Ruysch, who, noting his daughter's artistic talents, invited Willem van Aelst to be her teacher. In 1695 she married the painter Juriaen Pool (1665/1666–1745), whose portrait of her (circa 1715) shares a number of facial characteristics with her (much earlier) image in Musscher's painting. See *Dutch Portraits from the Seventeenth Century* [exh. cat., Museum Boymans-van Beuningen] (Rotterdam, 1995), 168, no. 57, ill.

137. Meijer (see note 134) suggests that the painting may well be identical to a work identified as "'t Floreren van de Edele schilderkonst door M. van Musscher" (the flourishing of the noble art of painting by M. van Musscher) that was no. 46 in the sale of the Jacob de Flines collection in Amsterdam on 20 March 1720. The iconographic tradition in which a female artist personifies Pictura is extensive. See, for example, Jan Brueghel the Elder's painting of this subject illustrated in Brenninkmeijer-de Rooij 1996, 54, fig. 53.

138. For a discussion of theoretical issues related to flower painting, see Taylor 1995, 77–113.

CHECKLIST

PAINTINGS

1
Willem van Aelst
Dutch, 1626–1683
Vanitas Flower Still Life, c. 1656
oil on canvas
55.9 x 46.4 (22 x 18¼)
North Carolina Museum of Art,
Raleigh, Purchased with funds
from the state of North Carolina

2
Balthasar van der Ast
Dutch, 1593/1594–1657
Basket of Flowers, c. 1622
oil on panel
17.8 x 23.5 (7 x 9¼)
National Gallery of Art,
Gift of Mrs. Paul Mellon

3
Balthasar van der Ast
Dutch, 1593/1594–1657
Basket of Fruit, c. 1622
oil on panel
18.1 x 22.8 (7⅛ x 9)
National Gallery of Art,
Gift of Mrs. Paul Mellon

4
Balthasar van der Ast
Dutch, 1593/1594–1657
*Bouquet on a Ledge with Landscape
Vista*, 1624
oil on copper
13.3 x 10.2 (5¼ x 4)
The Henry H. Weldon Collection

5
Balthasar van der Ast
Dutch, 1593/1594–1657
Flowers in a Wan-li Vase, c. 1625
oil on panel
36.3 x 27.7 (14⁵⁄₁₆ x 10⅞)
Private Collection

6
Balthasar van der Ast
Dutch, 1593/1594–1657
*Still Life of Flowers, Shells, and Insects on a
Stone Ledge*, mid-1630s
oil on panel
23 x 34.3 (9¹⁄₁₆ x 13½)
Pieter C.W.M. Dreesmann

7
Christoffel van den Berghe
Dutch, active 1617–1642
Still Life with Flowers in a Vase, 1617
oil on copper
37.6 x 29.5 (14¹³⁄₁₆ x 11⅝)
Philadelphia Museum of Art,
John G. Johnson Collection

8
Ambrosius Bosschaert the Elder
Dutch, 1573–1621
Still Life with Flowers, 1612–1614
oil on copper
23.2 x 18.1 (9⅛ x 7⅛)
Teresa Heinz (and the late
Senator John Heinz)

9
Ambrosius Bosschaert the Elder
Dutch, 1573–1621
Roses in an Arched Window, 1618–1619
oil on copper
27.5 x 23 (10¹³⁄₁₆ x 9¹⁄₁₆)
Private Collection, Holland

10
Ambrosius Bosschaert the Elder
Dutch, 1573–1621
Vase of Roses in a Window, 1618–1619
oil on copper
28 x 23 (11 x 9¹⁄₁₆)
Private Collection, Boston

11
Ambrosius Bosschaert the Elder
Dutch, 1573–1621
Bouquet of Flowers in a Glass Vase, 1621
oil on copper
31.6 x 21.6 (12⁷⁄₁₆ x 8½)
National Gallery of Art,
Patrons' Permanent Fund and
New Century Fund

12
Jan Brueghel the Elder
Flemish, 1568–1625
Flowers in a Glass Vase, c. 1608
oil on panel
42.9 x 33.7 (16⁷⁄₈ x 13¼)
Private Collection

13
Jan Brueghel the Elder
Flemish, 1568–1625
*A Basket of Mixed Flowers and a Vase of
Flowers*, 1615
oil on panel
54.9 x 89.9 (21⅝ x 35⅜)
National Gallery of Art,
Gift of Mrs. Paul Mellon,
in honor of the 50th anniversary
of the National Gallery of Art

14
Jacques de Gheyn II
Dutch, 1565–1629
Still Life with Flowers, c. 1602/1604
oil on copper
diameter: 17.8 (7)
Teresa Heinz (and the late
Senator John Heinz)

15
Cornelis de Heem
Dutch, 1631–1696
*Still Life of Fruit and Flowers with a
Roemer*, mid-1660s
oil on canvas
49.5 x 41.9 (19 ½ x 16 ½)
Private Collection, Washington

16
Jan Davidsz. de Heem
Dutch, 1606–1683/1684
Vase of Flowers, c. 1660
oil on canvas
69.6 x 56.5 (27 ⅜ x 22 ¼)
National Gallery of Art,
Andrew W. Mellon Fund

17
Joris Hoefnagel
Flemish, 1542–1600
*Flower Still Life with Alabaster
Vase*, c. 1595
oil on copper
22.7 x 17.2 (8 ¹⁵⁄₁₆ x 6 ¾)
Teresa Heinz (and the late
Senator John Heinz)

18
Jan van Huysum
Dutch, 1682–1749
*Still Life of Flowers and Fruit in a
Niche*, c. 1710/1715
oil on panel
81.6 x 62.9 (32 ⅛ x 24 ¾)
Private Collection

19
Jan van Huysum
Dutch, 1682–1749
Still Life with Flowers and Fruit, c. 1715
oil on panel
79 x 59.1 (31 ⅛ x 23 ¼)
National Gallery of Art,
Patrons' Permanent Fund and
Gift of Philip and Lizanne
Cunningham

20
Jan van Kessel the Elder
Flemish, 1626–1679
Vanitas Still Life, c. 1665
oil on copper
20.3 x 15 (8 x 5 ⅞)
National Gallery of Art,
Gift of Maida and George Abrams

21
Nicolaes Lachtropius
Dutch, active 1656–c. 1700
*Bouquet of Flowers on a Marble
Ledge*, 1680
oil on canvas
59.4 x 53 (23 ⅜ x 20 ⅞)
Teresa Heinz (and the late
Senator John Heinz)

22
Michiel van Musscher
Dutch, 1645–1705
*Allegorical Portrait of an Artist, Probably
Rachel Ruysch*, c. 1680/1685
oil on canvas
114.1 x 91.1 (44 ¹⁵⁄₁₆ x 35 ⅞)
North Carolina Museum of Art,
Raleigh, Gift of Armand and
Victor Hammer

23
Ludger tom Ring the Younger
German, 1522–1584
Vase of Wild Flowers on a Ledge, c. 1565
oil on panel
61.3 x 41 (24 ⅛ x 16 ⅛)
Teresa Heinz (and the late
Senator John Heinz)

24
Roelandt Savery
Dutch, 1576–1639
Flowers in a Roemer, 1603
oil on copper
32.1 x 48.4 (12 ⅝ x 19 ¹⁄₁₆)
Anonymous lender in honor of
Frank and Janina Petschek

25
Daniel Seghers and
Cornelis Schut the Elder
Flemish, 1590–1661;
Flemish, 1597–1655
*Garland of Flowers with a
Cartouche*, c. 1630
oil on panel
100.3 x 68.6 (39 ½ x 27)
Teresa Heinz (and the late
Senator John Heinz)

26
Jan Philips van Thielen
Flemish, 1618–1667
*Roses and Tulips and Jasmine in a Glass
with a Dragonfly and a Butterfly*, 1650s
oil on panel
32.1 x 23.9 (12 ⅝ x 9 ⁷⁄₁₆)
National Gallery of Art,
Gift of Mrs. Paul Mellon

27
Simon Pietersz. Verelst
Dutch, 1644–1721
Double Daffodils in a Vase, c. 1665
oil on panel
43 x 34.5 (16 ¹⁵⁄₁₆ x 13 ⁹⁄₁₆)
Wadsworth Atheneum, Hartford,
Connecticut, Gift of Mrs. Arthur L.
Erlanger

DRAWINGS

28
Anonymous Italian, c. 1500
Hellebore from Iconographica Botanicae
bodycolor on paper
27.3 x 20.3 (10 ¾ x 8)
Dumbarton Oaks, Washington,
Trustees for Harvard University

29
Anonymous Italian, c. 1500
Smirnium from Iconographica Botanicae
bodycolor on paper
28.6 x 19.1 (11 ¼ x 7 ½)
Dumbarton Oaks, Washington,
Trustees for Harvard University

30
Albrecht Dürer
German, 1471–1528
Tuft of Cowslips, inscribed "1526/AD"
gouache on vellum
19.3 x 16.8 (7 ⅝ x 6 ⅝)
National Gallery of Art,
The Armand Hammer Collection

31
Antoni Henstenburgh
Dutch, active early-
to-mid 18th century
Five Tulips
watercolor and bodycolor
on vellum
37.3 x 20.2 (14 ¹¹⁄₁₆ x 7 ¹⁵⁄₁₆)
Abrams Collection, Boston

32
Pieter Holsteyn the Younger
Dutch, c. 1614–1673
*Pink-and-Red Variegated
Carnation*, c. 1670
watercolor and bodycolor
on paper
27.6 x 17.5 (10 ⅞ x 6 ⅞)
Collection of Mrs. Paul Mellon,
Upperville, Virginia

33
Pieter Holsteyn the Younger
Dutch, c. 1614–1673
White Carnation, c. 1670
watercolor and bodycolor
on paper
27.6 x 17.5 (10 7/8 x 6 7/8)
Collection of Mrs. Paul Mellon,
Upperville, Virginia

34
Jan van Huysum
Dutch, 1682–1749
Bouquet of Flowers, c. 1720
black chalk and gray wash
on paper
35.6 x 27.9 (14 x 11)
Private Collection, Washington

35
Jan van Huysum
Dutch, 1682–1749
Bouquet of Flowers, 1723
black chalk and gray wash
on paper
38.1 x 29.2 (15 x 11 1/2)
Private Collection, Washington

36
Jacob Marrel
German, 1614–1681
Admiral d'Hollande from
Tulpenboek, 1642
bodycolor on paper
31.4 x 20.3 (12 3/8 x 8)
Collection of Mrs. Paul Mellon,
Upperville, Virginia

37
Jacob Marrel
German, 1614–1681
Geel en Root van Leven from
Tulpenboek, 1642
bodycolor on paper
31.4 x 20.3 (12 3/8 x 8)
Collection of Mrs. Paul Mellon,
Upperville, Virginia

38
Jacob Marrel
German, 1614–1681
General De Man from *Tulpenboek*, 1642
bodycolor on paper
31.4 x 20.3 (12 3/8 x 8)
Collection of Mrs. Paul Mellon,
Upperville, Virginia

39
Jacob Marrel
German, 1614–1681
Le Grand Incarnadin from
Tulpenboek, 1642
bodycolor on paper
31.4 x 20.3 (12 3/8 x 8)
Collection of Mrs. Paul Mellon,
Upperville, Virginia

40
Jacob Marrel
German, 1614–1681
Title Page from *Tulpenboek*, 1642
bodycolor on paper
31.4 x 20 (12 3/8 x 7 7/8)
Collection of Mrs. Paul Mellon,
Upperville, Virginia

41
Herman Saftleven
Dutch, 1609–1685
A Mullein Pink, 1680
watercolor and bodycolor
over graphite on paper
20 x 15.7 (7 7/8 x 6 3/16)
Abrams Collection, Boston

42
Peter Withoos
Dutch, 1654–1693
Fritillaria meleagris, 1683
gouache on paper
32.1 x 20.5 (12 5/8 x 8 1/16)
Abrams Collection, Boston

MANUSCRIPTS

43
Anonymous Flemish, c. 1500
The Annunciation from *Book of Hours*
(*Warburg Hours*)
illumination on vellum
open: 11.4 x 19.1 (4 1/2 x 7 1/2)
Library of Congress, Rare Book
and Special Collections Division

44 (not in exhibition)
Julius François de Geest
Dutch, c. 1639–1699
Fritillaria, Johnny-Jump-Ups, and Vinca
from *Jardin de rares et curieux fleurs*,
mid-1660s
bodycolor on vellum
open: 30.5 x 45.1 (12 x 17 3/4)
Collection of Mrs. Paul Mellon,
Upperville, Virginia

45
Joris Hoefnagel
Flemish, 1542–1600
Iris from *Animalia Rationalia et Insecta*,
(*Ignis*), c. 1575/1580
watercolor and gouache
on vellum
open: 15 x 40.2 (5 7/8 x 15 7/8)
National Gallery of Art,
Gift of Mrs. Lessing J. Rosenwald

46
Jacques Le Moyne de Morgues
French, c. 1533–1588
*Damask Rose and a Purple-and-Blue Wild
Pansy (Heartsease)* from a manuscript
of 16 miniatures of flowers and
insects, probably 1570s
watercolor and bodycolor on gold
ground on vellum
open: 11.4 x 15.2 (4 1/2 x 6)
Dumbarton Oaks, Washington,
Trustees for Harvard University

47
Jan Withoos
Dutch, 1648–c. 1685
Johnny-Jump-Up (*Viola tricolor*) from
A Collection of Flowers, c. 1670
bodycolor on vellum
open: 41.6 x 57.2 (16 3/8 x 22 1/2)
Collection of Mrs. Paul Mellon,
Upperville, Virginia

48
Jan Withoos
Dutch, 1648–c. 1685
Morning Glory from *A Collection of
Flowers*, c. 1670
bodycolor on vellum
open: 41.6 x 58.7 (16 3/8 x 23 1/8)
Collection of Mrs. Paul Mellon,
Upperville, Virginia

PRINTED BOOKS

49
Anonymous Follower of Hans
Vredeman de Vries
Netherlandish, 1527–c. 1606
Garden of Love appended to Hans
Vredeman de Vries' *Hortorum
Viridariorumque* (Antwerp), 1583
open: 23.5 x 64.8 (9 ¼ x 25 ½)
Dumbarton Oaks, Washington,
Trustees for Harvard University

50
Otto Brunfels
German, 1464–1534
Narcissus from *Herbarum Vivae Eicones*
(Strasbourg), 1530
hand-colored
open: 30.5 x 43.2 (12 x 17)
Dumbarton Oaks, Washington,
Trustees for Harvard University

51
Johann Theodor de Bry
Flemish, 1561–c. 1623
Narcissi from *Florilegium*
(Amsterdam), 1612
open: 30.5 x 39.4 (12 x 15 ½)
The Folger Shakespeare Library,
Washington

52
Rembert Dodoens
Netherlandish, 1517–1585
Wild Poppies from *Cruijdeboeck*
(Antwerp), 1552–1554
hand-colored
open: 32.4 x 45.7 (12 ¾ x 18)
Dumbarton Oaks, Washington,
Trustees for Harvard University

53
Rembert Dodoens
Netherlandish, 1517–1585
Sunflower from *Florum et Coronariarum
Odoratarumque Nonnullarum Herbarum
Historia* (Antwerp, 2d edition),
1569
open: 17.5 x 22.9 (6 ⅞ x 9)
Dumbarton Oaks, Washington,
Trustees for Harvard University

54
Christian Egenolph
German, 1502–1555
Variety of Plants from *Herbarium.
Arborum, Fruticum Imagines*
(Frankfurt), c. 1550
hand-colored
open: 20.3 x 29.2 (8 x 11 ½)
The Folger Shakespeare Library,
Washington, Gift of Mary P.
Massey

55
Leonhart Fuchs
German, 1501–1566
*Portrait of Three Artists at Work and Wild
Basil* from *De Historia Stirpium
Commentarii Insignes* (Basel), 1542
hand-colored
open: 35.6 x 50.8 (14 x 20)
Dumbarton Oaks, Washington,
Trustees for Harvard University

56
Jacob Hoefnagel after Joris
Hoefnagel
Flemish, 1573–1632/1635
Emblematic Page from *Archetypa
Studiaque Patris Georgii Hoefnagelii*
(Frankfurt), 1592
open: 24.5 x 66.8 (9 ⅝ x 26 ¼)
National Gallery of Art,
Gift of Mrs. Lessing J. Rosenwald

57
Crispijn van de Passe the Younger
Dutch, c. 1597–c. 1670
Crocus from *Hortus Floridus*
(Arnhem), 1614
hand-colored
open: 19.1 x 55.3 (7 ½ x 21 ¾)
Collection of Mrs. Paul Mellon,
Upperville, Virginia

58
Crispijn van de Passe the Younger
Dutch, c. 1597–c. 1670
Sunflowers from *Le Jardin de fleurs*
(Arnhem), 1614
open: 19.1 x 56.2 (7 ½ x 22 ⅛)
Collection of Mrs. Paul Mellon,
Upperville, Virginia

59
Crispijn van de Passe the Younger
Dutch, c. 1597–c. 1670
Spring Garden from *Hortus Floridus*
(Utrecht), 1614
open: 19.1 x 54.6 (7 ½ x 21 ½)
The Folger Shakespeare Library,
Washington

60
Crispijn van de Passe the Younger
Dutch, c. 1597–c. 1670
Cyclamen from *Le Jardin de fleurs*
(Utrecht), 1615
open: 19.1 x 54.6 (7 ½ x 21 ½)
The Folger Shakespeare Library,
Washington

61
Adriaen Pietersz. van de Venne
Dutch, 1589–1662
*Ex minimis patet ipse Deus (God is revealed
in the smallest work of his creation)*
from *Zeevsche nachtegael*
(Middelburg), 1623
open: 24.5 x 39.5 (9 ⅝ x 15 ⁹⁄₁₆)
National Gallery of Art, Library

SELECTED BIBLIOGRAPHY

Amsterdam 1984
Segal, Sam, ed. *Masters of Middelburg* [exh. cat., Kunsthandel K. and V. Waterman] (Amsterdam, 1984).

Amsterdam 1993–1994
Luijten, Ger, et al., eds. *Dawn of the Golden Age: Northern Netherlandish Art 1580–1620* [exh. cat., Rijksmuseum] (Amsterdam, 1993–1994).

Amsterdam and 's-Hertogenbosch 1982
Segal, Sam. *A Flowery Past: A Survey of Dutch and Flemish Flower Painting from 1600 until the Present* [exh. cat., Gallery P. de Boer and Noordbrabants Museum] (Amsterdam and 's-Hertogenbosch, 1982).

Antwerp 1993
Botany in the Low Countries (End of the 15th Century–ca. 1650) [exh. cat., Museum Plantin Moretus and Stedelijk Prentenkabinet] (Antwerp, 1993).

Bergstrom 1956
Bergström, Ingvar. *Dutch Still-Life Painting in the Seventeenth Century*. Trans. Christina Hedström and Gerald Taylor. London, 1956.

De Bie 1661
De Bie, Cornelis. *Het Gulden cabinet van edel de vry schilderconst*. Antwerp, 1661.

Blunt 1994
Blunt, Wilfrid. *The Art of Botanical Illustration: An Illustrated History*. Mineola, N.Y., 1994.

Bol 1956
Bol, Laurens J. "Een Middelburgse Brueghel-groep." *Oud Holland* 71 (1956).

Bol 1960
Bol, Laurens J. *The Bosschaert Dynasty. Painters of Flowers and Fruit*. Leigh-on-Sea, 1960.

Boom 1975–1976
Boom, Florence Hopper. "An Early Flower Piece by Jacques de Gheyn II." *Simiolus* 8 (1975–1976), 195–198.

Brenninkmeijer-de Rooij 1996
Brenninkmeijer-de Rooij, Beatrijs. *Roots of Seventeenth-Century Flower Painting: Miniatures, Plant Books, Paintings*. Leiden, 1996.

De Bry 1591
De Bry, Theodor. *Brevis Narratio Eorum Quae in Florida Americae Provincia Gallis Acciderunt*. Frankfurt, 1591.

Caen and Paris 1990–1991
Tapić, Alain. *Les Vanités dans la peinture au XVIIe siècle* [exh. cat., Musée des Beaux-Arts and Musée du Petit Palais] (Caen and Paris, 1990–1991).

Cats 1625
Cats, J. *Houwelyck*. Middelburg, 1625.

Cats 1627
Cats, Jacob. *Proteus ofte minne-beelden verandert in sinne-beelden*. Rotterdam, 1627.

Cologne and Utrecht 1985–1986
Roelant Savery in Seiner Zeit (1576–1639) [exh. cat., Wallraf-Richartz-Museum and Centraal Museum] (Cologne and Utrecht, 1985–1986).

Davidson and Van der Weel 1996
Davidson, Peter, and Adriaan van der Weel, trans. *A Selection of the Poems of Sir Constantijn Huygens (1596–1687)*. Amsterdam, 1996.

Erasmus 1564
Erasmus, Desiderius. *Adagiorum*. Antwerp, 1564.

Fat and De Jong 1991
Fat, L. Tjon Sie, and E. de Jong, eds. *The Authentic Garden: A Symposium on Gardens*. Leiden, 1991.

Freedberg 1981
Freedberg, David. "The Origins and Rise of the Flemish Madonnas in Flower Garlands." In *Münchner Jahrbuch der Bildenden Kunst*. 3d series. Munich, 1981.

Van Gool 1750
Van Gool, Johan. *De Nieuwe schouburg der Nederlandtsche kunstschilders en schilderessen*. The Hague, 1750.

Gordon 1985
Gordon, Lesley. *The Mystery and Magic of Trees and Flowers*. Exeter, 1985.

Grant 1954
Grant, Maurice Harold. *Jan van Huysum, 1682–1749*. Leigh-on-Sea, 1954.

The Hague 1992
The Mauritshuis in Bloom: Bouquets from the Golden Age. [exh. cat., Mauritshuis] (The Hague, 1992).

Hendrix 1984
Hendrix, Marjorie Lee. "Joris Hoefnagel and the Four Elements: A Study in Sixteenth-Century Nature Painting." Ph.D. diss., Princeton University, 1984.

Hexham 1648
Hexham, Hendrick. *Dictionarium, ofte woorden-boeck, begrijpende den schat der Nederlandtsche tale, met de Engelsche uytlegginge*. 2 vols. Rotterdam, 1648. (2d edition by Daniel Manly. Rotterdam, 1675–1678).

Houbraken 1753
Houbraken, Arnold. *De Groote schouburgh der Nederlandsche konstschilders en schilderessen*. The Hague, 1753.

Hulton 1977
Hulton, Paul. *The Work of Jacques Le Moyne de Morgues: A Huguenot Artist in France, Florida, and England*. London, 1977.

Hunt and De Jong 1988
Hunt, John Dixon, and Erik de Jong, eds. *The Anglo-Dutch Garden in the Age of William and Mary. Journal of Garden History* 8 (1988).

Jones 1988
Jones, Pamela M. "Federico Borromeo as a Patron of Landscapes and Still Lifes. Christian Optimism in Italy ca. 1600." *The Art Bulletin* 70 (1988), 261–272.

De Jongh 1976
De Jongh, Eddy, et al. *Tot Lering en vermaak: Betekenissen van Hollandse genrevoorstellingen uit de zeventiende eeuw* [exh. cat., Rijksmuseum] (Amsterdam, 1976).

Kaufmann 1993
Kaufmann, Thomas DaCosta. *The Mastery of Nature: Aspects of Art, Science, and Humanism in the Renaissance*. Princeton, 1993.

Koreny 1985
Koreny, Fritz. *Albrecht Dürer and the Animal and Plant Studies of the Renaissance*. Boston, 1985.

Lawrence 1983
Stokstad, Marilyn, and Jerry Stannard. *Gardens of the Middle Ages* [exh. cat., Spencer Museum of Art] (Lawrence, Kans., 1983).

London 1996
Taylor, Paul. *Dutch Flower Painting, 1600–1750* [exh. cat., Dulwich Picture Gallery] (London, 1996).

Van Mander 1604
Van Mander, Karel. *Het Schilderboeck*. Haarlem, 1604.

Munich 1997
Vignau-Wilberg, Thea. *Durch die Blume: Natursymbolik um 1600.* [exh. cat., Staatliche Graphische Sammlung München] (Munich, 1997).

Münster 1996
Segal, Sam. "Blumen, Tiere und Stilleben von Ludger tom Ring d. J." In *Die Maler tom Ring.* Ed. Angelika Lorenz [exh. cat., Westfälisches Landesmuseums für Kunst und Kulturgeschichte] (Münster, 1996).

Panofsky 1971
Panofsky, Erwin. *The Life and Art of Albrecht Dürer.* Princeton, 1971.

Paris 1985
Le Héraut du dix-septième siècle: Dessins et gravures de Jacques de Gheyn II et III [exh. cat., Institut Néerlandais] (Paris, 1985).

Pittsburgh 1986
Bridson, Gavin D.R., Donald E. Wendel, et al. *Printmaking in the Service of Botany* [exh. cat., Hunt Institute for Botanical Documentation, Carnegie-Mellon University] (Pittsburgh, 1986).

Pliny
Pliny, *Historia naturalis.* Trans. W. H. S. Jones. Vol. 7, book 25, section 4 (Cambridge and London, 1956).

Prest 1981
Prest, John. *The Garden of Eden: The Botanic Garden and the Re-Creation of Paradise.* New Haven and London, 1981.

Reeds 1976
Reeds, Karen Meier. "Renaissance Humanism and Botany." *Annals of Science* 33 (1976), 519–542.

Reznicek 1961
Reznicek, E.K.J. *Die Zeichnungen von Hendrick Goltzius.* 2 vols. Utrecht, 1961.

Saunders and De Gex 1997
Saunders, Gill, and Jenny de Gex. *So Many Sweet Flowers: A Seventeenth-Century Florilegium. Paintings by Johann Walther 1654.* London, 1997.

Schatborn 1994
Schatborn, Peter. *Flowers and Plants.* Amsterdam, 1994.

Schlie 1900
Schlie, Friedrich. "Sieben Briefe und eine Quittung von Jan van Huijsum." *Oud-Holland* 18 (1900), 141.

Segal 1982
Segal, Sam. "The Flower Pieces of Roelandt Savery." In *Leids Kunsthistorisch Jaarboek* (Leiden, 1982).

Segal 1987
Segal, Sam. *Tulips by Anthony Claesz.* Maastricht, 1987.

Segal 1990
Segal, Sam. *Netherlandish Flower Painting of Four Centuries.* Amstelveen, 1990.

Taylor 1995
Taylor, Paul. *Dutch Flower Painting 1600–1720.* New Haven and London, 1995.

Tongiorgi Tomasi 1997
Tongiorgi Tomasi, Lucia. *An Oak Spring Flora: Flower Illustration from the Fifteenth Century to the Present Time.* Upperville, Va., 1997.

Veldman 1993
Veldman, Ilja M. "Keulen als toevluchtsoord voor Nederlandse kunstenaars (1567–1612)." *Oud Holland* 107 (1993), 34–57.

Van de Venne 1623
Van de Venne, Adriaen Pietersz. *Zeevsche nachtegael.* Middelburg, 1623.

Verwey 1971
Verwey, H. de la Fontaine. "The Binder Albert Magnus and the Collectors of His Age." *Quaerendo* 1/3 (1971), 158–178.

Vienna 1987
Thoss, Dagmar. *Flämische Buchmalerei: Handschriftenschätze Burgunderreich* [exh. cat., Österreichische Nationalbibliothek] (Vienna, 1987).

Vignau-Wilberg 1994
Vignau-Wilberg, Thea. *Archetypa Studiaque Patris Georgii Hoefnagelii: Nature, Poetry and Science in Art around 1600.* Munich, 1994.

De Villiers 1987
De Villiers, E.S. "Flemish Art Theory in the Second Half of the Seventeenth Century—An Investigation on an Unexplored Source." *South African Journal of Art History* 2 (1987), 1–11.

De Vries 1583
De Vries, Hans Vredeman. *Hortorum Viridariorumque.* Antwerp, 1583.

Washington 1986
Hand, John Oliver, et al. *The Age of Bruegel: Netherlandish Drawings in the Sixteenth Century* [exh. cat., National Gallery of Art] (Washington, 1986).

Washington 1988
Brown, Beverly Louise, and Arthur K. Wheelock Jr. *Masterworks from Munich: Sixteenth-to-Eighteenth-Century Paintings from the Alte Pinakothek* [exh. cat., National Gallery of Art] (Washington, 1988).

Washington 1989
Wheelock Jr., Arthur K., ed. *Still Lifes of the Golden Age: Northern European Paintings from the Heinz Family Collection* [exh. cat., National Gallery of Art] (Washington, 1989).

Wheelock 1995
Wheelock Jr., Arthur K. *Dutch Paintings of the Seventeenth Century.* New York and Oxford, 1995.

White 1964
White, Christopher. *The Flower Drawings of Jan van Huysum.* Leigh-on-Sea, 1964.

Winckelmann-Rhein 1969
Winckelmann-Rhein, Gertraude. *The Paintings and Drawings of Jan "Flower" Brueghel.* New York, 1969.